AMERICA'S BEST IDEA

A Photographic Journey Through Our National Parks

PHOTOGRAPHS BY

STAN JORSTAD

ESSAYS BY

Alfred Runte
Edwin Bernbaum
Ruth Rudner

EDITED BY

Mark J. Saferstein
Christopher E. Stein

©2006, 2008 APN Media, LLC
Published by *American Park Network*
1775 Broadway, Suite 622
New York, New York 10019
212.581.3380
www.AmericanParkNetwork.com

Designer: Michael Cohen
Scans and reproduction: Bruce Starrenburg/Lightbox
Printed by: Oceanic Graphic Printing

Photographs ©2006 Stan Jorstad
The photographs in this book, taken mostly with a
Fujica Panorama G617 Professional, are all film-based,
non-manipulated images.

Second edition, 2008
Printed and bound in China
ISBN-10: 0-9787101-1-8
ISBN-13: 978-0-9787101-1-8
Library of Congress Control Number: 2006931969

Dedicated to my late wife, Wanda, for her care, support and love, and to
the men and women dressed in the green and gray of the National Park Service.

Stan Jorstad

Contents

America's Best Idea is arranged in chronological order based on the year each park first received protection as public land. National parks often received other names and designations when first set aside. (For example, Zion National Park was originally designated Mukuntuweap National Monument.) The following pages provide a history of names, dates and designations of all our national parks, along with beautiful, iconic images of each of these special places. The table of contents includes the original name and designation of each national park, along with the year it was first protected (in parentheses).

New Terms for Conservation

by Alfred Runte, Ph.D.

By the mid 20th century, emerging challenges in the worldwide conservation movement led to three new categories of protected lands—wilderness, biosphere reserves and world heritage sites.

The idea of wilderness was born in the United States. National parks and national forests—and whole expanses of the south-western deserts—gloriously invited the perception of nature with no trace of humans. Indeed, the key to wilderness was an abundance of public lands that had rarely attracted settlers. Few countries but the United States could lay claim to that prerequisite.

Beginning in the 1920s, wilderness advocates commonly charged that the National Park System had been overdeveloped in the pursuit of commercial tourism. In their view, the preservation of natural landscapes required the absence of roads and structures. Likewise, the national forests had lost the spirit of wilderness to commercial logging, grazing and mining.

In 1924, the U.S. Forest Service designated the first unofficial wilderness in New Mexico's Gila National Forest. Initially called primitive or roadless areas, others soon followed across the west. However, each was an administrative designation that could always be changed by the agency. The proponents of wilderness were not satisfied and looked to federal legislation.

In 1935, the founding of the Wilderness Society launched a formal campaign for congressional protection of wilderness. Thirty years later, spurred by the environmental movement, Congress approved the Wilderness Act of 1964. Finally, "wilderness" had been legally defined as "an area where the earth and its community of life are untrammeled by man, where man himself is a visitor who does not remain." Wilderness should further retain "its primeval character and influence, without permanent improvements or human habitation," including "outstanding opportunities for solitude or a primitive and unconfined type of recreation."

Initially, Congress designated 9.1 million acres as wilderness, all of it in the national forests. However, the Wilderness Act further required the Department of the Interior to begin wilderness studies in the national parks and wildlife refuges, such studies to include all roadless areas exceeding 5,000 acres. The Alaska National Interest Lands Conservation Act of 1980 and the California Desert Protection Act of 1994 further secured wilderness as a management principle governing the nation's public lands.

On the world stage, however, the idea of American wilderness was impractical. Alaska and the Rocky Mountains hardly compared with the Amazon, for example. The American west was in a category all its own. High country was not valued for settlement; even American Indians had preferred the plains. In Alaska, where native interests and wilderness had clashed, there had been ample room for compromise. However, ecosystems not secured by mountainous terrain or arctic remoteness defied the idea of wilderness. In much of the developing world—in areas of great population—the ideal of wilderness could not be sustained.

Increasingly, conservationists looked to the United Nations, established in 1945, to determine how best to protect the planet. In 1971, the United Nations established its Programme on Man and the Biosphere (MAB). MAB, a division of UNESCO (the United Nations Educational, Scientific and Cultural Organization), suggestively admitted in its very title that people and the environment were forever linked. Inhabited lands rather than wilderness applied to the vast majority of the world. The need for a new classification became obvious— biosphere reserve. As distinct from wilderness, "where man

himself is a visitor who does not remain," the object of a biosphere reserve was to ensure man's presence, in the words of UNESCO, "reconciling the conservation of biodiversity with economic development."

In short, a biosphere reserve enlisted compromise, lest the people living closest to it not be supportive. Outside the core of a protected area and its buffer, a transition zone allowed development. The object of a biosphere reserve remained sustainability for both people and the land. Ideally, any community could learn to respect its surroundings and responsibly develop a resource base. Allowed that base, the community would be energized to support those lands most in need of absolute protection, again, the core of the reserve.

As of 2005, 102 countries had joined the program, maintaining 482 biosphere reserves. Where America's national parks met the definition, many, too, had been included. Worldwide, however, the principal distinction remained. In preserving the Amazon basin, for example, or the game lands of South Africa, the needs of local residents and traditional resource uses demanded tolerance and flexibility.

A third category, world heritage site, strengthened the growing perception that biological and cultural resources—wherever located—mattered to the entire world. Did Yellowstone belong to the United States or to the human race? Were the pyramids Egypt's shrines alone or would their loss be felt by everyone? UNESCO determined that such sites "of outstanding natural and cultural importance" were indeed "the common heritage of humankind."

An obvious distinction was the focus given to cultural resources. Generally, wilderness and biosphere reserves were limited to natural resources. Suddenly, a world heritage site could be a

building complex or even an entire city. So had determined UNESCO's Convention Concerning the Protection of the World Cultural and Natural Heritage, adopted in 1972. Officially ratified in 1975, the treaty provided for the World Heritage Programme and World Heritage Committee, which was charged with accepting nominations.

As of 2005, UNESCO listed 182 counties as participants, protecting 812 separate sites (628 cultural, 160 natural and 24 "mixed properties"). Cultural resources include the pyramids of Giza, the Statute of Liberty in New York Harbor and the Great Wall of China. Significant natural resources include surviving portions of the Atlantic rain forest in southern Brazil, notably Salto Morato, the first private reserve accepted as a world heritage site.

Among America's national parks, fourteen are world heritage sites: Yellowstone, Everglades, Grand Canyon, Redwood, Mammoth Cave, Olympic, Great Smoky Mountains, Yosemite, Hawai'i Volcanoes, Carlsbad Caverns, Mesa Verde, Wrangell-St. Elias, Glacier Bay and Glacier. Obviously, the term has its problems, suggesting a specificity that great natural areas obviously defy. Still, in a planetary sense they are "sites," objects of affection for the world.

Admittedly, there is something artificial about defining any landscape, especially when many worthy places remain undesignated for protection. Some areas may achieve all three designations and other areas not even one. The point is to remember the hint of desperation that underlies the entire process. Each is an attempt to win new converts, not necessarily to be exact. The need for definition is to ensure restraint. Parts of the world that would recoil at the thought of wilderness have often accepted the next best thing. However difficult it may be to categorize conservation, the necessity is equally clear.

An independent scholar and environmental historian, Alfred Runte, Ph.D., writes for an international audience on the issues of parks and transportation. His books include National Parks: The American Experience; Yosemite: The Embattled Wilderness *and* Allies of the Earth: Railroads and the Soul of Preservation. *Currently, he is advising Ken Burns in the production of a film series about national parks, to be aired in 2009 on PBS.*

The Spiritual and Cultural Significance of National Parks

by Edwin Bernbaum, Ph.D.

The remarkable landscapes and features of nature preserved in national parks have the power to awaken an extraordinary sense of wonder. The ethereal rise of a peak in mist, the smooth glide of an eagle in flight, the bright slant of sunbeams piercing the depths of a primeval forest—such glimpses of natural beauty can move people in inexplicable ways. National parks transport visitors far outside the confines of routine existence, to awe-inspiring realms of mystery and splendor, governed by forces beyond our control. By coming to national parks, many seek to transcend the superficial distractions that clutter daily life and experience something of deeper, enduring value. Indeed, these sanctuaries of unspoiled nature represent places of spiritual renewal where we can return to the source of our being and recover the freshness of a new beginning.

In addition to their scientific value as repositories of geological and biological diversity and knowledge, national parks have profound spiritual and cultural significance for the American people. The idea of nature as a place of inspiration and renewal played a key role in the creation of the National Park Service in 1916. For example, a primary motivation of the early conservationist John Muir for working to establish Yosemite National Park, was to preserve Yosemite Valley as "a temple far finer than any made by human hands." A recent study by the National Parks Conservation Association (NPCA) found that the most compelling message galvanizing public support for national parks is that they "provide us with some of the most beautiful, majestic and awe-inspiring places on earth." The beauty and grandeur of national parks have inspired major works of art, photography, literature and music. Thomas Moran's dramatic paintings of Yellowstone and Albert Bierstadt's of Yosemite Valley helped draw national attention to these remarkable places. Ansel Adams' images of ageless trees and monumental mountains evoke a realm of timeless beauty preserved in national parks. North Cascades National Park has enshrined fire lookouts and viewpoints where beat poets, such as Gary Snyder and Philip Whalen, found inspiration for some of their most memorable poetry. The composer Ferde Grofé was so overwhelmed by his visit to the Grand Canyon that he felt he could not express his feelings in words and could only communicate his experience through music—thus composing his most famous work, the Grand Canyon Suite.

National parks function as cultural icons of national heritage and identity. For many, they preserve the pristine essence and pioneering spirit of America. Parents take their families

on trips to national parks as secular pilgrimages—to become familiar with national landmarks that enshrine the values, ideals and origins of our nation. A close second as a compelling message in the NPCA study was "Our national parks are the legacy we leave our children." Icons such as Yellowstone, Yosemite and the Grand Canyon have come to represent the nation as a whole, while the glacier-clad peak of Mount Rainier has become an evocative symbol of the Pacific Northwest. Much of the attraction of Great Smoky Mountains, the most visited national park, comes from its association with Appalachian and Cherokee cultures.

National parks enshrine important American values and aspirations. The high peaks and deep canyons of parks such as Denali and the Grand Canyon embody the majesty and grandeur of America extolled in the national hymn "America the Beautiful." The vast landscapes and untrammeled places preserved within the National Park System serve as reminders of the quest for freedom and independence that lies at the heart of American culture and history. High mountains and remote wilderness areas in parks such as Grand Teton, North Cascades and Wrangell-St. Elias provide opportunities for the kinds of challenge and adventure that build character and contribute to America's can-do spirit. Many go to primeval forests and quiet spots in Redwood, Rocky Mountain and other national parks as natural cathedrals, seeking to find peace and contemplation—and to recover a sense of who they are and what is important in life.

American Indians, along with the native cultures of Hawai'i, Alaska and Samoa, attach many of their deepest spiritual values to sacred places, beliefs, practices and traditions connected to lands that are now within national parks. The Hopi and other tribes of the Colorado Plateau come on pilgrimages to Mesa Verde National Park to perform rituals at the cliff dwellings of the Anasazi, their mysterious ancestors. The Cherokees look to the Great Smoky Mountains as their ancestral homeland and regard the rounded summits such as Clingman's Dome as places of refuge and healing, and sources of life-giving rivers. Native Hawaiians revere the lava and vegetation of Kilauea Volcano in Hawai'i Volcanoes National Park as the sacred domain and body of Pele, the volcano goddess, who brings life and fertility through her fiery energy. The Blackfeet, Lakota and other high plains American Indians hold sun dances and go on vision quests at ceremonial sites within national parks such as Glacier and Badlands. The National Park Service changed the name of Mount McKinley National Park in Alaska to Denali National Park and Preserve in deference to the traditional Koyukon name for the highest peak in North America. (Denali means "The High One.") The National Park of American Samoa helps to safeguard the customs, beliefs and traditions of Samoa, the "sacred earth" of the Samoan people.

Finally, national parks hold special value and attraction for people of all cultures, both in the United States and around the world. Japanese Americans living in the Pacific Northwest, for example, refer to Mount Rainier as "Tacoma Fuji," linking the mountain to the sacred volcano that serves as the symbol of their homeland of Japan. African Americans can take special pride in the Buffalo Soldiers who helped safeguard Yosemite, Sequoia and others in their early days. People from all over the world come to visit national parks in the United States to learn about establishing similar sanctuaries in their own countries. America's "best idea" has become a model for protecting special places around the earth and a major contribution to world culture.

Edwin Bernbaum, Ph.D., is Director of the Sacred Mountains Program at The Mountain Institute, where he works with national park personnel to develop interpretive materials based on the cultural and spiritual significance of different features found in mountain environments. He is the author of the award-winning book Sacred Mountains of the World, the basis for an exhibit at the Smithsonian Institution, and lectures widely to audiences in places such as the Smithsonian, the Metropolitan Museum of Art, the National Geographic Society and the American Museum of Natural History.

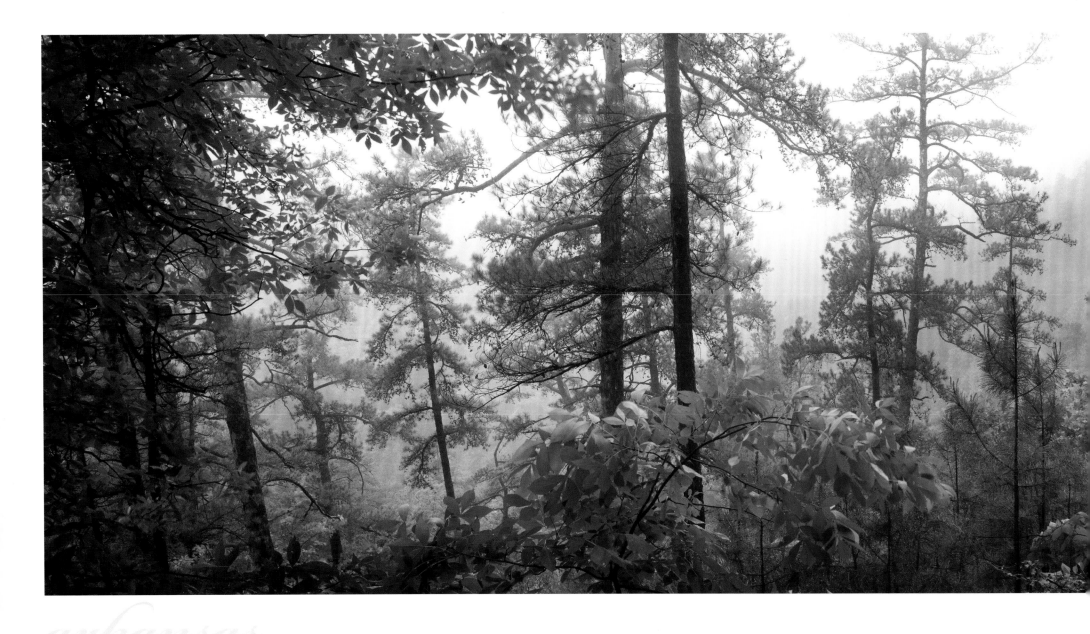

arkansas

Taking into consideration the very picturesque scenery around, the great variety of minerals, the... mineral springs, and the vast quantity of hot water which issues from the side of a mountain... makes this, perhaps the most romantic spot on the face of the earth, and a place containing more natural curiosities than any other....

- Early settler Hiram Abiff Whittington in a letter dated March 3, 1833

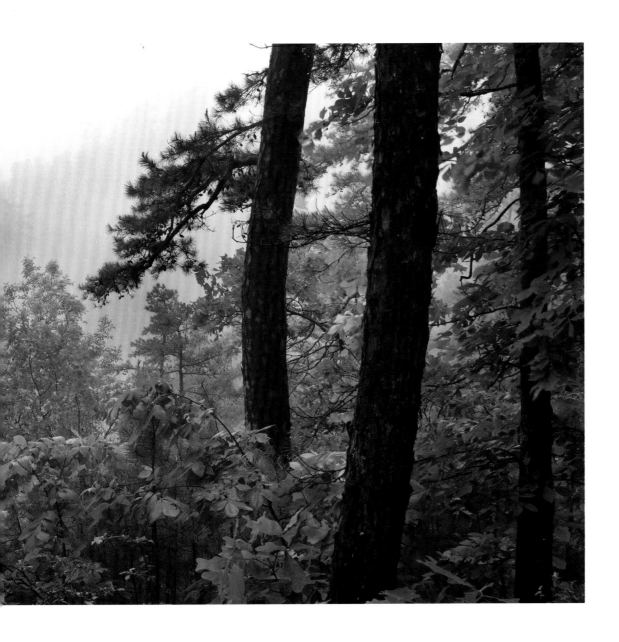

HOT SPRINGS

Located in the Ouachita Mountains, this park protects forty-seven hot springs supplying water for thermal baths still in use today. Eight palatial bathhouses form Bathhouse Row, a National Historic Landmark District. Scenic drives and hiking trails wind through the park's forested mountains.

Chronology of Designations
1832 · Hot Springs Reservation
1921 · Hot Springs National Park

5,550 acres

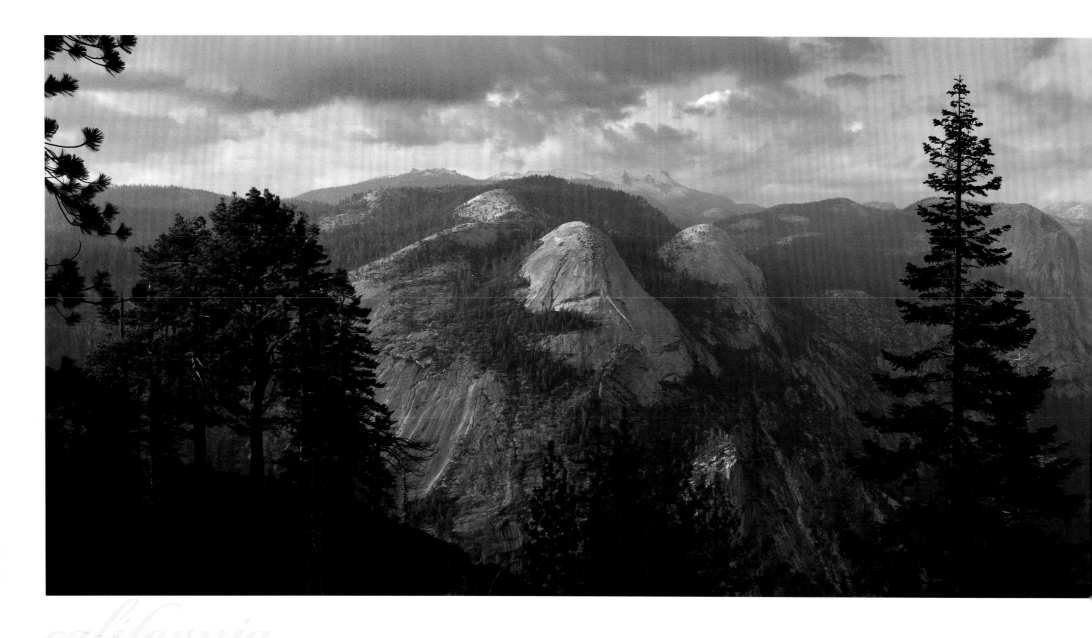

california

I invite you to join me in a months worship with Nature in the high temples of the great Sierra Crown beyond
our holy Yosemite. It will cost you nothing save the time and very little of that for you will be mostly in Eternity.

- John Muir to Ralph Waldo Emerson, 1871

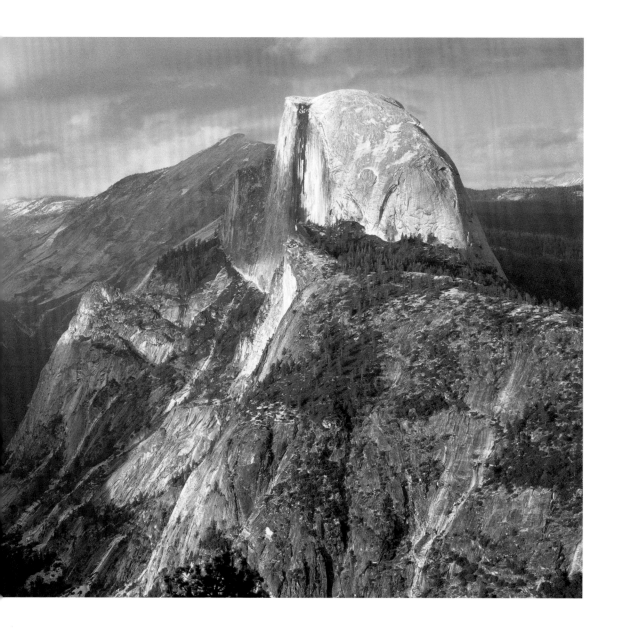

YOSEMITE

Granite peaks and domes rise high above broad meadows carpeted with wildflowers in the heart of the Sierra Nevada. Groves of Giant Sequoias dwarf other trees. Tall mountains, alpine lakes and waterfalls—including the nation's highest—are all found here in this vast wilderness.

Chronology of Designations
1864 · Yosemite Grant
1890 · Yosemite National Park
1984 · World Heritage Site
1984 · Wilderness Area (94%)

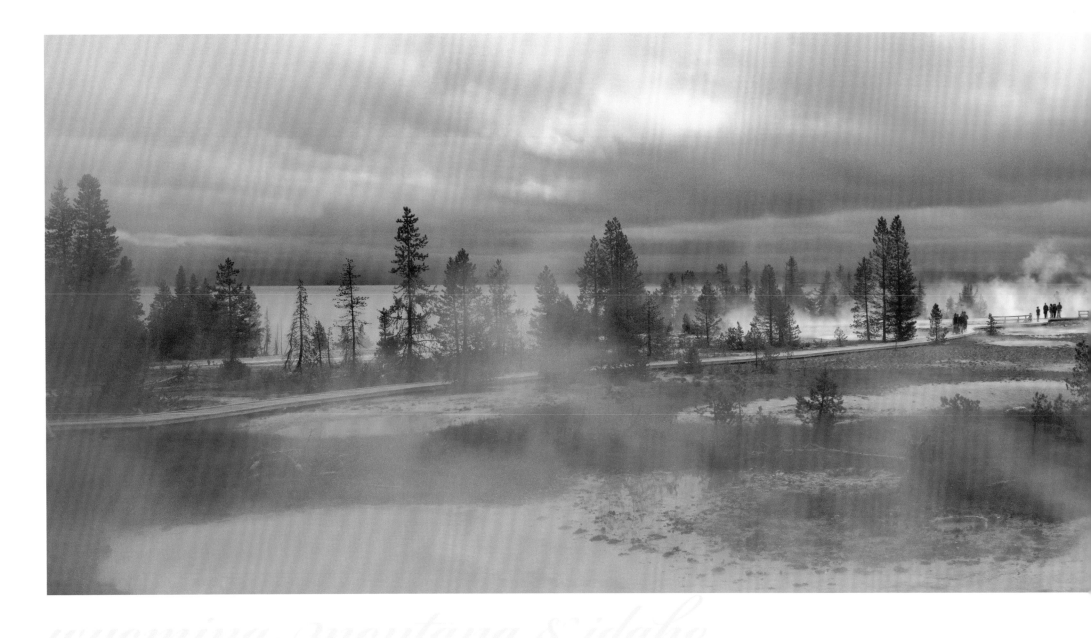

Be it enacted by the Senate and House of Representatives of the United States of America in Congress assembled, that the tract of land in the Territories of Montana and Wyoming, lying near the head-waters of the Yellowstone river... is hereby reserved and withdrawn from settlement... and dedicated and set apart as a public park or pleasuring-ground for the benefit and enjoyment of the people.

- Act of U.S. Congress, March 1, 1872

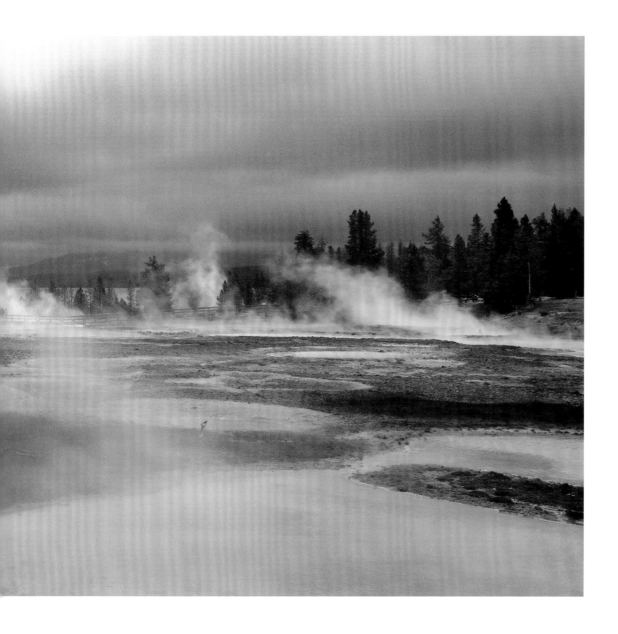

YELLOWSTONE

Old Faithful and some 10,000 other thermal features make this the Earth's greatest geyser area. Here, too, are lakes, waterfalls, high mountain meadows, wildlife and the Grand Canyon of the Yellowstone—all set aside as the world's first national park.

Chronology Of Designations
1872 · Yellowstone National Park
1972 · Wilderness Area recommended (91%)
1976 · Biosphere Reserve
1978 · World Heritage Site

2,221,766 acres

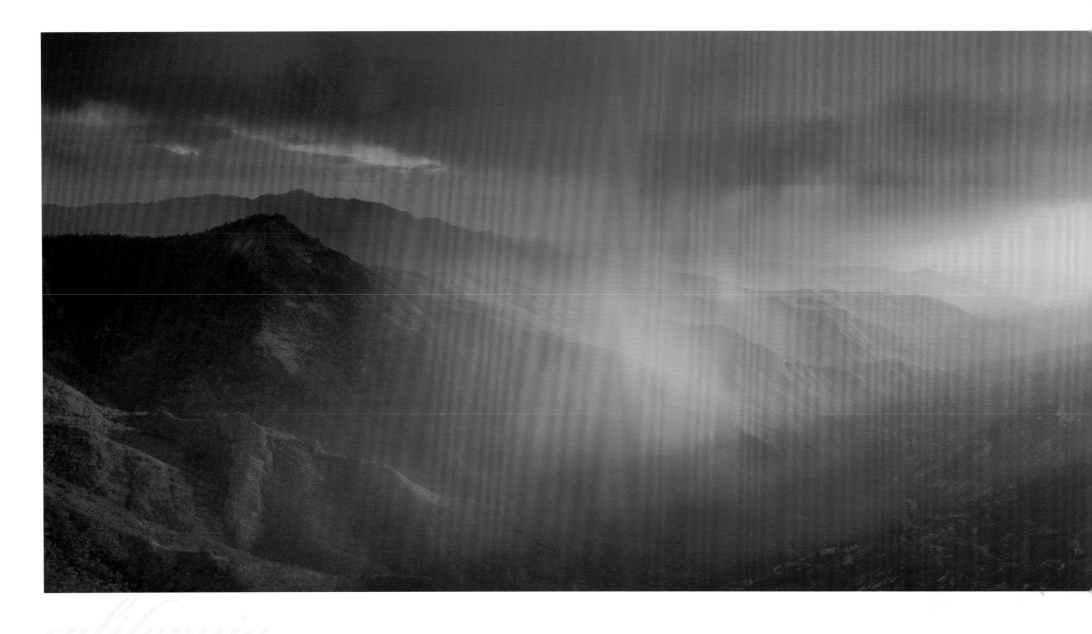

california

When I entered this sublime wilderness the day was nearly done… the trees with rosy, glowing countenances seemed to be hushed and thoughtful, as if waiting in conscious religious dependence on the sun, and one naturally walked softly and awe-stricken among them.

- John Muir

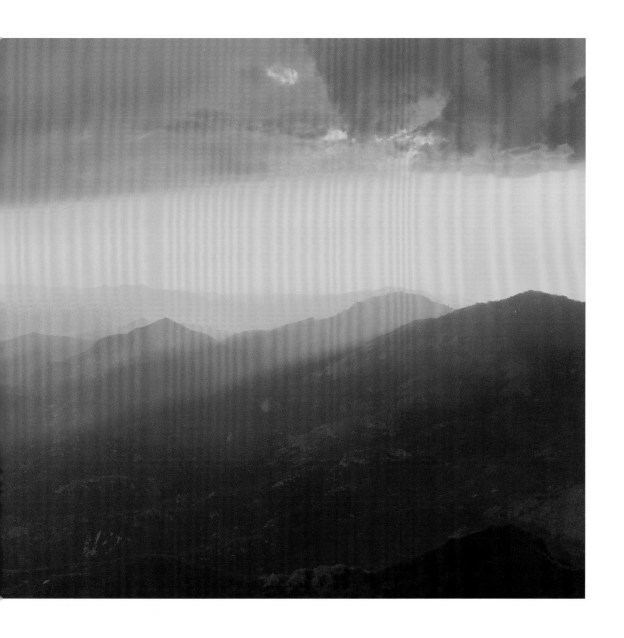

SEQUOIA

Great groves of Giant Sequoias, the world's largest living trees, and Mount Whitney, the highest mountain in the continental United States (14,495 feet), are spectacular attractions here in the Sierra Nevada.

Chronology of Designations
1890 · Sequoia National Park
1976 · Biosphere Reserve
1984 · Wilderness Area (68%)

406,426 acres

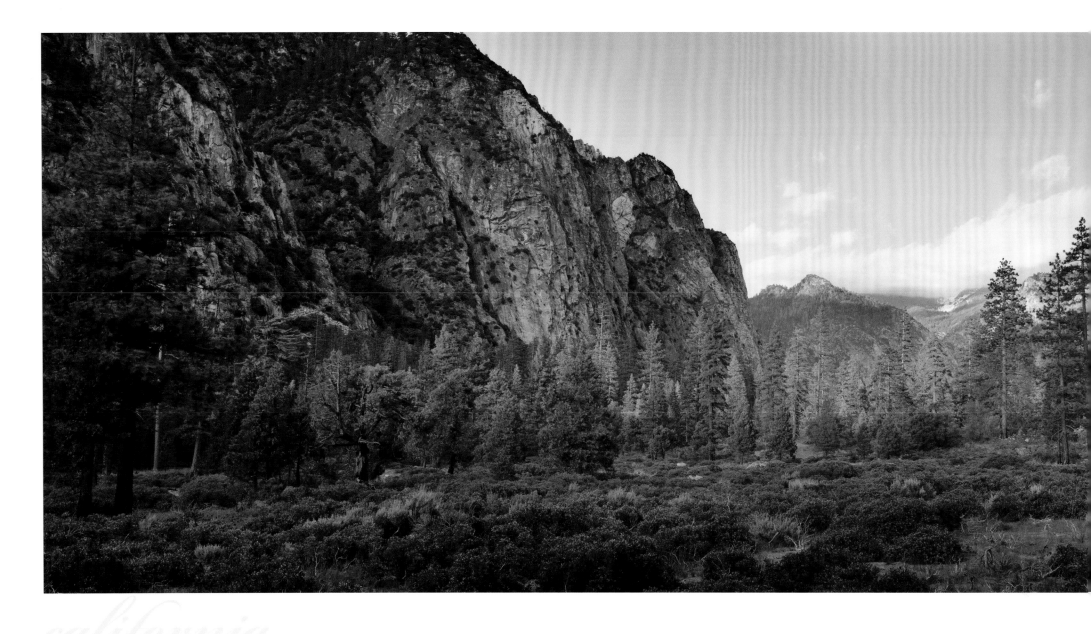

california

A thousand up-springing spires and pinnacles pierce the sky in every direction, and the cliffs and mountain ridges are everywhere ornamented with countless needle-like turrets... Whichever way we turned, we were met by extraordinary fullness of detail. Every mass seemed to have the highest possible ornamental finish. Along the lower flanks of the walls, tall, straight pines, the last of the forest, were relieved against the cliffs, and the same slender forms, although carved in granite, surmounted every ridge and peak.

- Clarence King, 1864

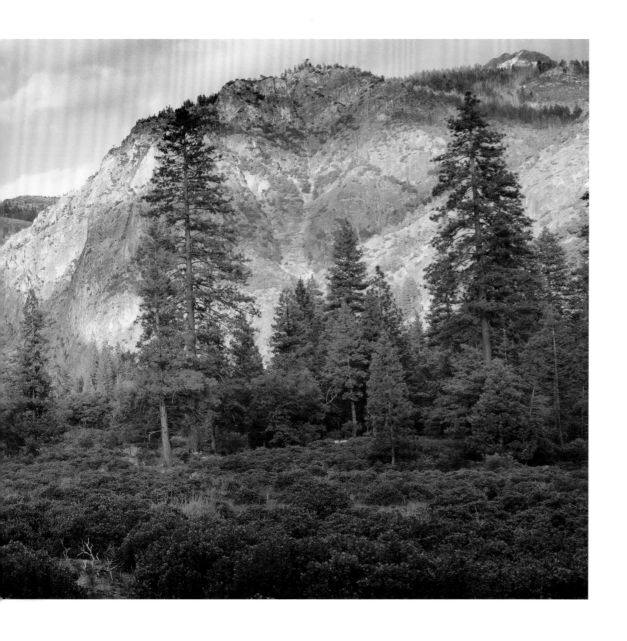

KINGS CANYON

Originally established to protect Giant Sequoia trees, this park was later greatly enlarged to include the grand glacial gorge that gives the park its modern name. The surrounding peaks of the Sierra Nevada add to the dramatic scenery of the park.

Chronology of Designations
1890 · General Grant National Park
1940 · Kings Canyon National Park
1984 · Wilderness Area (98%)

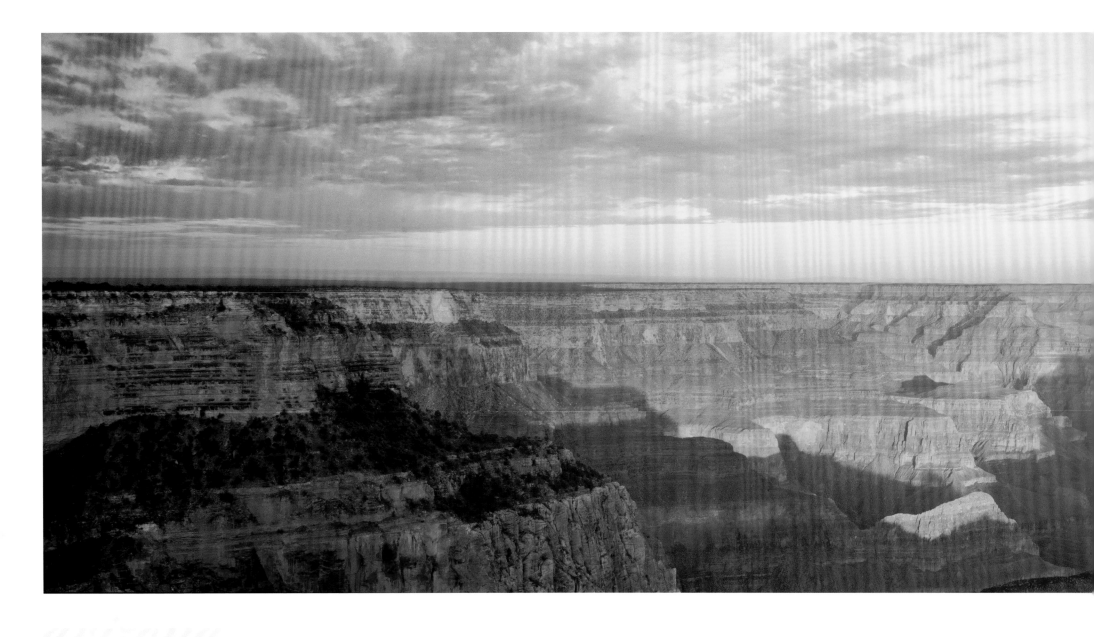

We regard ourselves as guardians of the canyon. Our way of protecting [sites] is by silence.
I would like my great-great-grandchildren to know this place the same way [I do].

- Rex Tilousi, Havasupai Elder

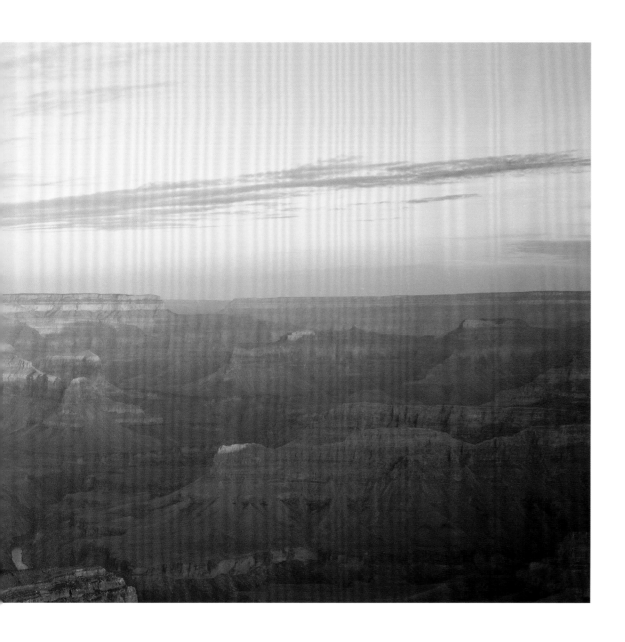

GRAND CANYON

The park, focusing on the world-famous Grand Canyon of the Colorado River, encompasses 277 miles of river, with adjacent forested uplands on the North and South Rims. The forces of erosion have exposed an immense variety of rock formations in this mile-deep canyon, illustrating vast periods of geological history.

Chronology of Designations
1893 · Grand Canyon Forest Reserve
1906 · Grand Canyon Game Preserve
1908 · Grand Canyon National Monument
1919 · Grand Canyon National Park
1979 · World Heritage Site
1979 · Wilderness Area proposed (91%)

1,217,403 acres

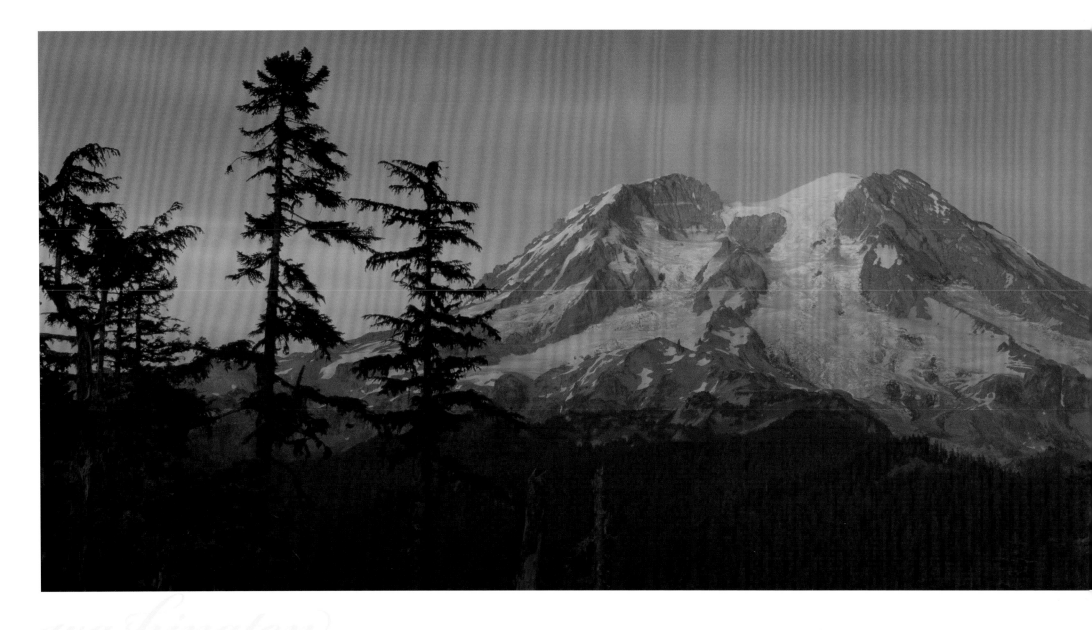

Ta-co-bet, Majestic Mountain, Silhouetted against our eastern sky
Guardian over the land of the Nisqually people
Who sends the rains to renew our spirits,
Who feeds the river, the home of our salmon,
Who protects our eagle in her flight,

Who reaches upward through the floating clouds,
To touch the hand of the Great Spirit,
Ta-co-bet
We honor you
The People of the Nisqually Tribe

- Cecelia Svinth Carpenter, Nisqually historian

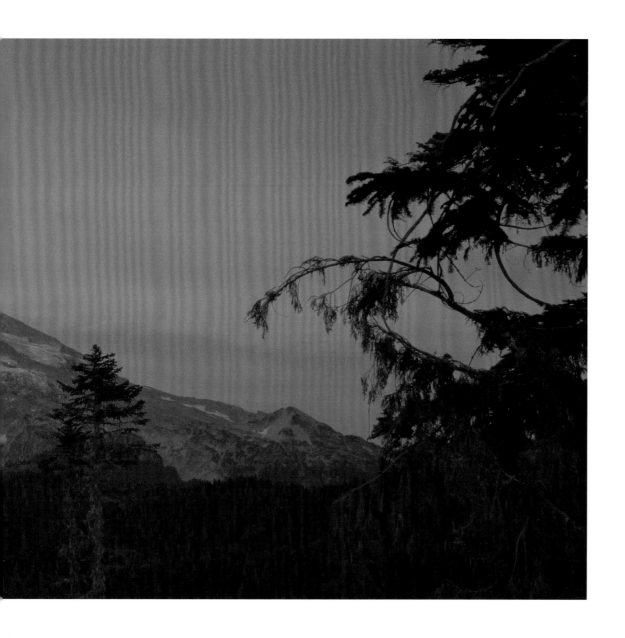

MOUNT RAINIER

In winter, this 14,410-foot active volcano is blanketed in a snowy white cloak. In summer, snow melts to reveal colorful lava layers, glacial ice, stunning wildflower meadows and lush old growth forests.

235,625 acres

Chronology of Designations
1899 · Mount Rainier National Park
1988 · Wilderness Area (97%)

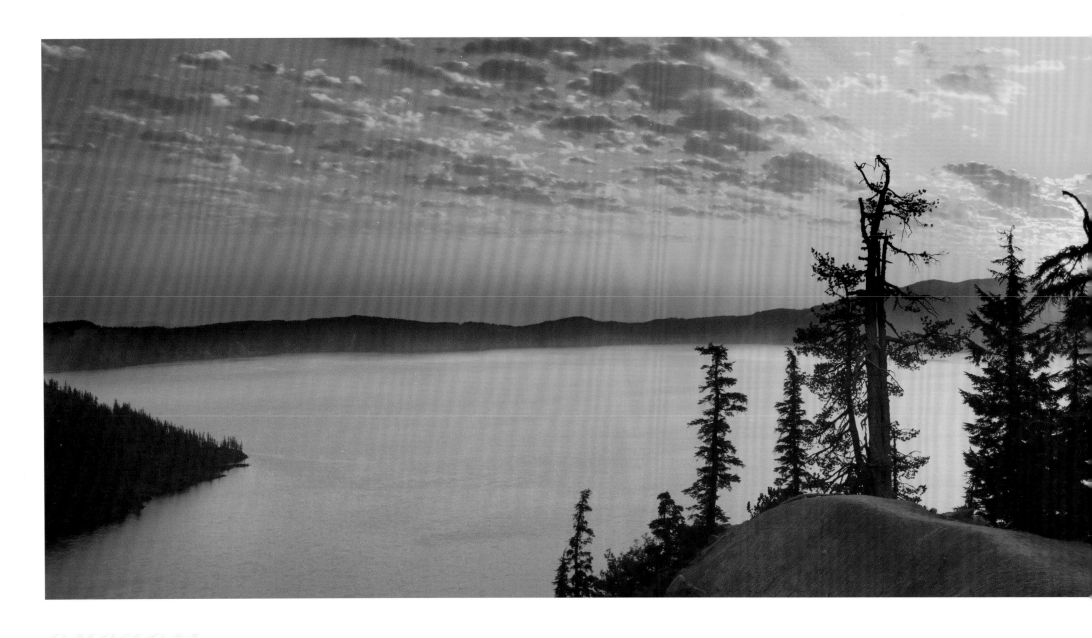

oregon

Few forget the first glimpses of Crater Lake on a clear summer's day—21 square miles of water so intensely blue it looks like ink, ringed by cliffs towering up 2,000 feet above its surface. The mountain bluebird, Indian legend says, was gray before dipping into Crater Lake's waters

- National Geographic, 1989

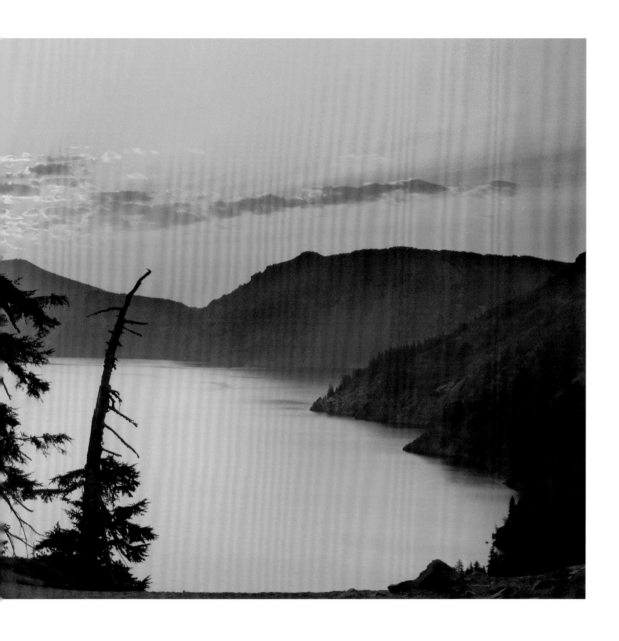

CRATER LAKE

Crater Lake lies within the caldera of Mount Mazama, a volcano of Oregon's Cascade Range that erupted around 7,700 years ago. The mountain collapsed, forming a caldera, eventually containing the deepest lake in the United States, at 1,943 feet deep.

Chronology of Designations
1902 · Crater Lake National Park
1978 · Wilderness Area recommended (74%)

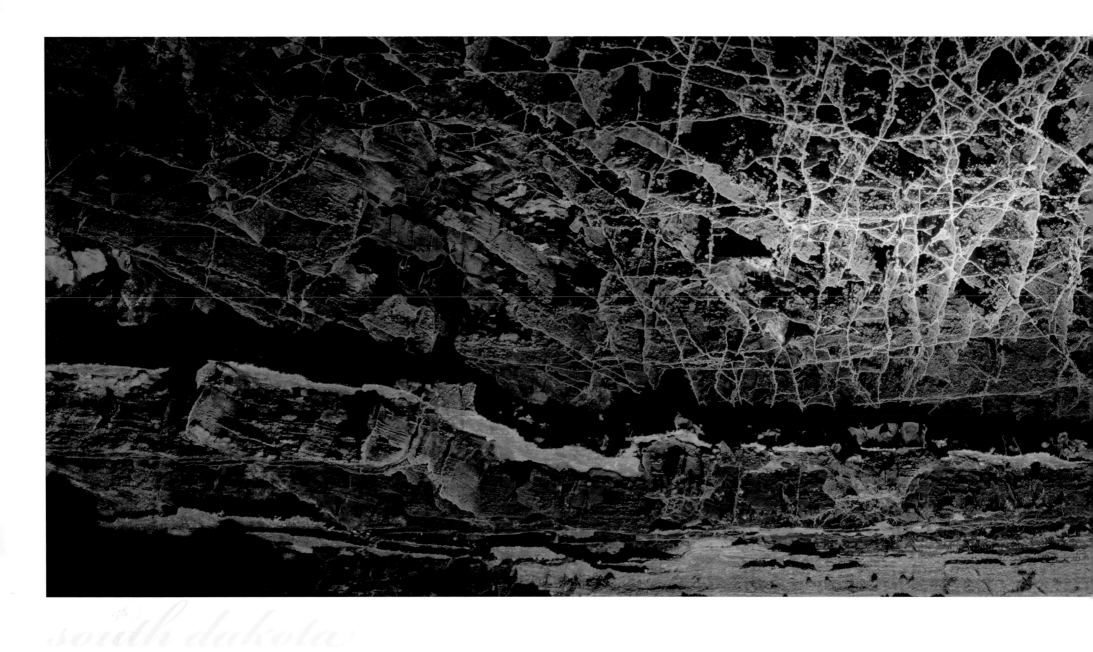

south dakota

Have given up the idea of finding the end of Wind Cave.

- Alvin F. McDonald, diary entry, January 23, 1891

WIND CAVE

This limestone cave in the scenic Black Hills is decorated by beautiful boxwork and calcite crystal formations. The park's mixed-grass prairie displays an impressive array of wildlife.

Chronology of Designations
1903 · Wind Cave National Park

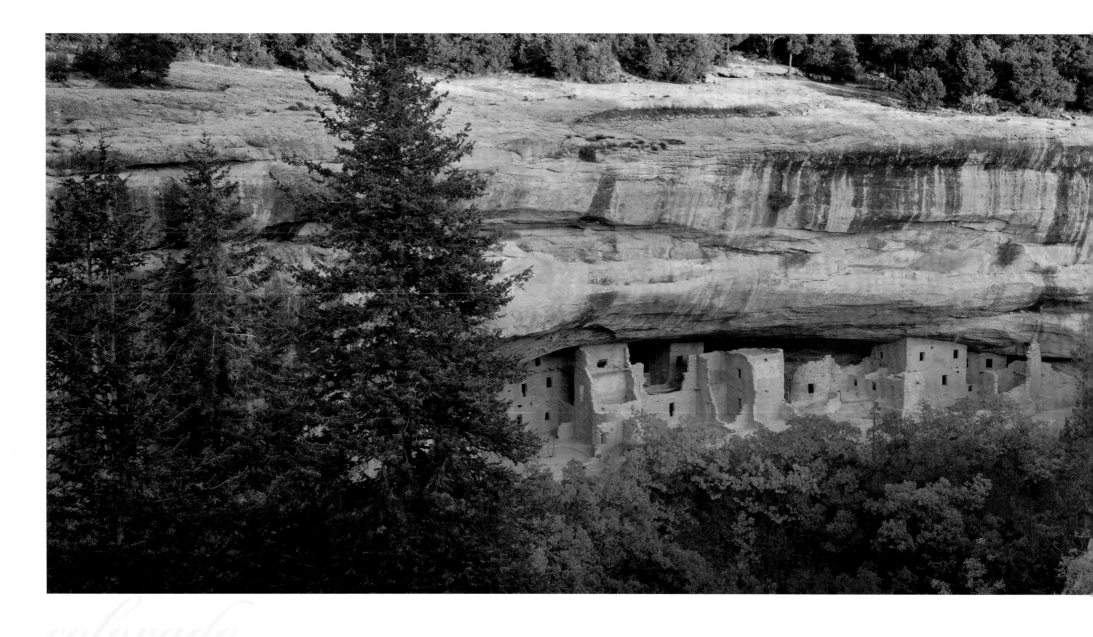

colorado

Tools, weapons and other objects rescued from ruins; in essence, all objects which have been used by people are endowed with sacredness because they are associated with the souls and with the sacred past.

- Alfonso Ortiz

MESA VERDE

These world-famous cliff dwellings and other works of the Ancestral Puebloan people are the most notable and best preserved in the entire United States.

Chronology of Designations
1906 · Mesa Verde National Park
1976 · Wilderness Area (16%)
1978 · World Heritage Site

52,122 acres

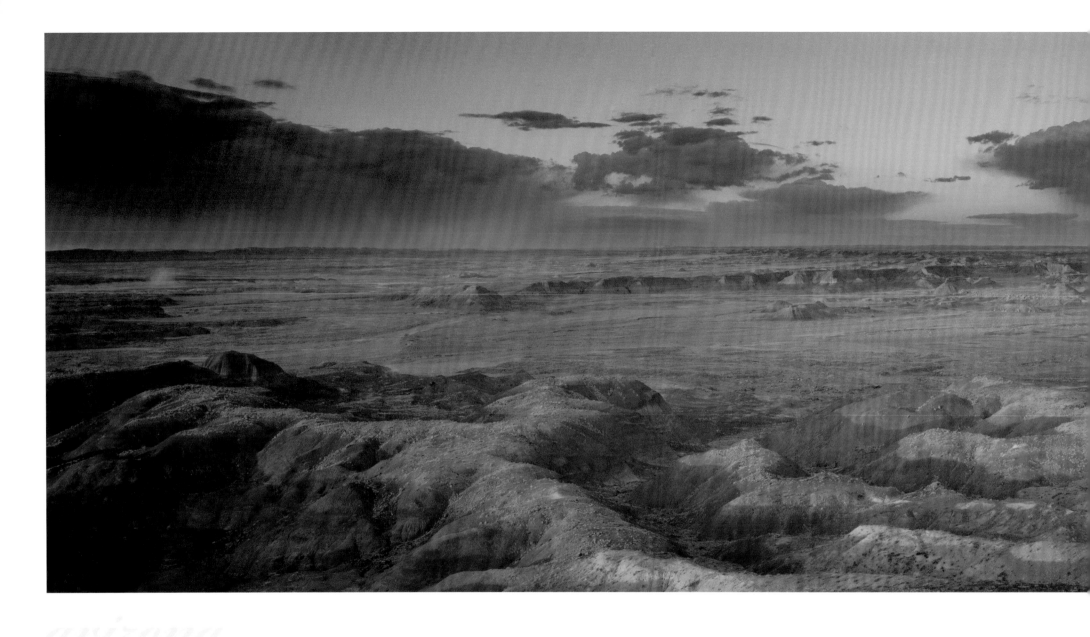

arizona

An enchanted spot… to stand on the glass of a gigantic kaleidoscope,
over whose sparkling surface the sun breaks in infinite rainbows.

- Charles F. Lummis, 1891

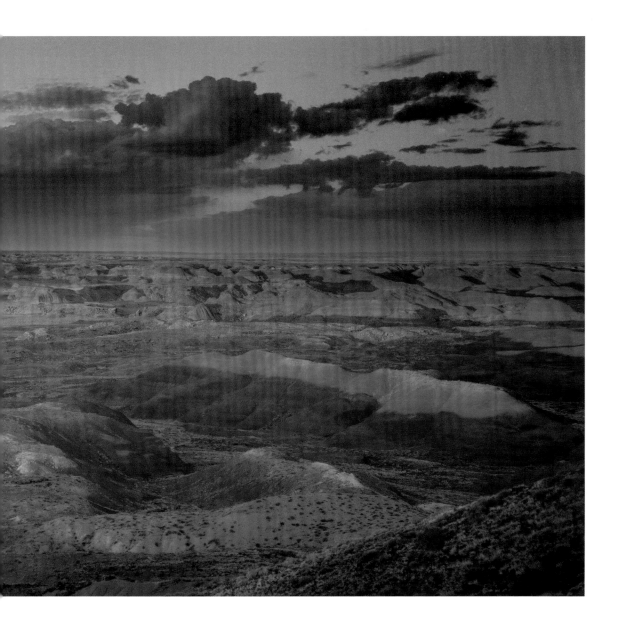

PETRIFIED FOREST

This park's primary feature is petrified logs composed of multicolored quartz. It also contains shortgrass prairie, portions of the Painted Desert and archeological, paleontological, historic and cultural resources.

Chronology of Designations
1906 · Petrified Forest National Monument
1962 · Petrified Forest National Park
1970 · Wilderness Area (53%)

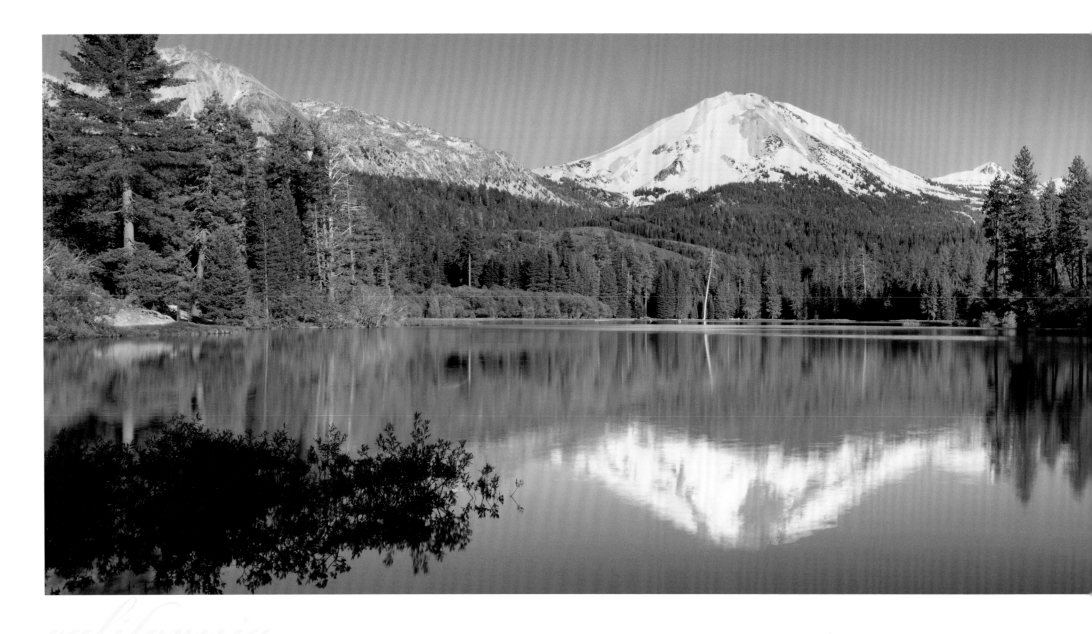

Long live Lassen... and may the good Lord defer the day when it gets such modern fripperies as showers, electric lights, roads that are too good, radios and other like nuisances, so that people who want to say they have been someplace will continue to go to Yosemite and Golden Gate Park where they can have commercialization, unappreciative crowds and noise, to their hearts content. Lets leave a few places where people can go and really enjoy nature.

- Douglas H. Strong

LASSEN VOLCANIC

Lassen Peak erupted intermittently from 1914 to 1921. Active vulcanism includes boiling springs, steaming fumaroles, mud pots and sulfurous vents.

Chronology of Designations
1907 · Lassen Peak and Cinder
 Cone National Monuments
1916 · **Lassen Volcanic National Park**
1972 · Wilderness Area (74%)

106,372 acres

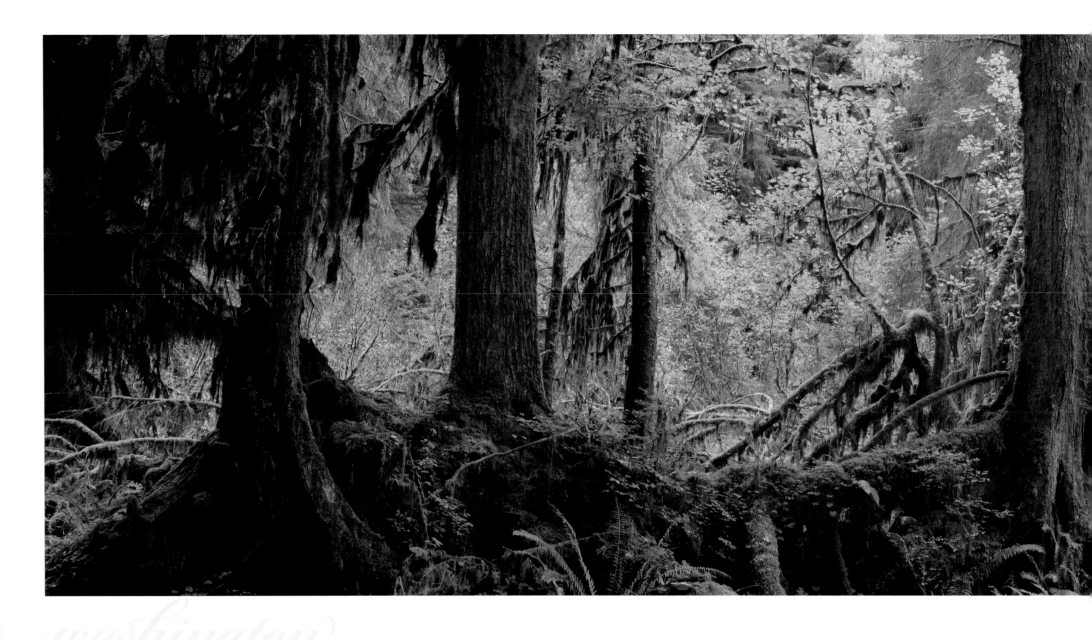

washington

We live with our ancestors in our hearts. Their voices speak of the trees, the water and all the earth's riches. We have the foundation of our Indian livelihood, culture and spiritual strengths that have existed for centuries.

- Jamestown S'Klallam
Tina Bridges and Kathy Duncan

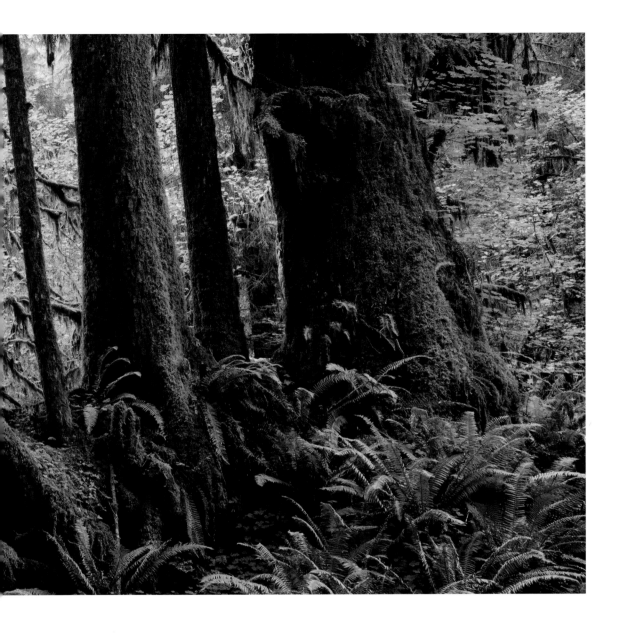

OLYMPIC

This park is a large wilderness area featuring a spectacular temperate rainforest, glacier-capped mountains, deep valleys, meadows, lakes, giant trees, 73 miles of unspoiled beaches and wildlife such as Roosevelt elk and Olympic marmot.

Chronology of Designations
 1909 · Mount Olympus National Monument
 1938 · Olympic National Park
 1976 · Biosphere Reserve
 1981 · World Heritage Site
 1988 · Wilderness Area (95%)

922,651 acres

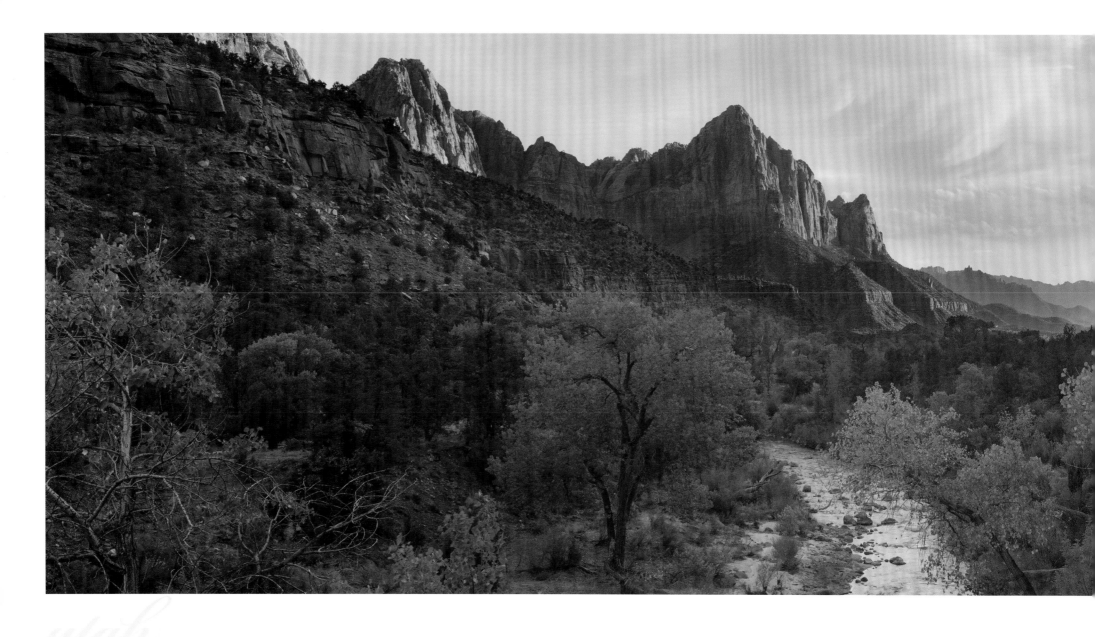

Nothing can exceed the wondrous beauty of Zion. In the nobility and beauty of the sculptures there is no comparison… There is an eloquence to their forms which stirs the imagination with a singular power and kindles in the mind a glowing response.

- Clarence E. Dutton, 1882

ZION

Colorful canyon and mesa scenery includes erosion and rock-fault patterns that create phenomenal shapes and landscapes. The elevation differences provide habitat for extremely diverse plant communities.

Chronology of Designations

1909 · Mukuntuweap National Monument

1918 · Zion National Monument

1919 · Zion National Park

1974 · Wilderness Area recommended (90%)

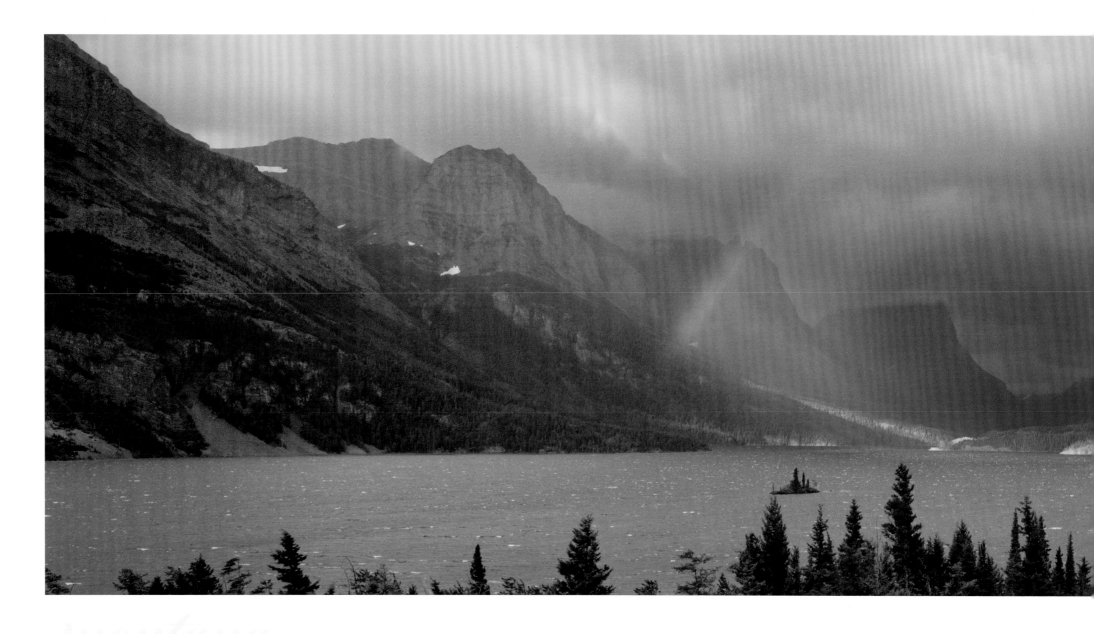

They [the mountains] seem to be marching; or, rather, they seem to have been checked and frozen in the midst of a lateral movement... Nearly every visitor has some comment on the peculiar Mayan-temple shape that characterizes so much of the mountain mass, and also on a certain dark arrow-band, with two light arrow-bands on each side of it, which is seen on the sides of so many of the peaks. Glacier National Park records a colossal event in our earth history.

- Freeman Tilden, 1951

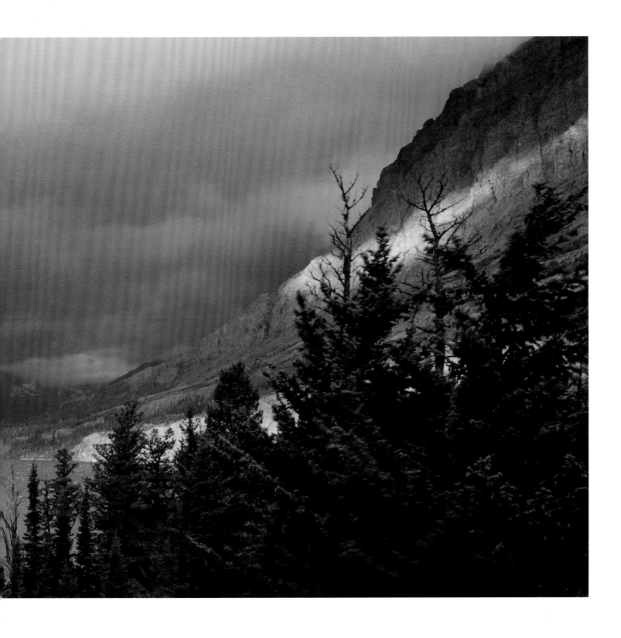

GLACIER

With precipitous peaks rising above ten thousand feet, this ruggedly beautiful land includes nearly thirty glaciers, numerous glacier-fed lakes and streams, a wide variety of wildflowers and wildlife including grizzly bears and gray wolves.

Chronology of Designations

1910 · **Glacier National Park**

1932 · Included in Waterton-Glacier
 International Peace Park

1974 · Wilderness recommended (91%)

1976 · Biosphere Reserve

1995 · World Heritage Site

1,013,594 acres

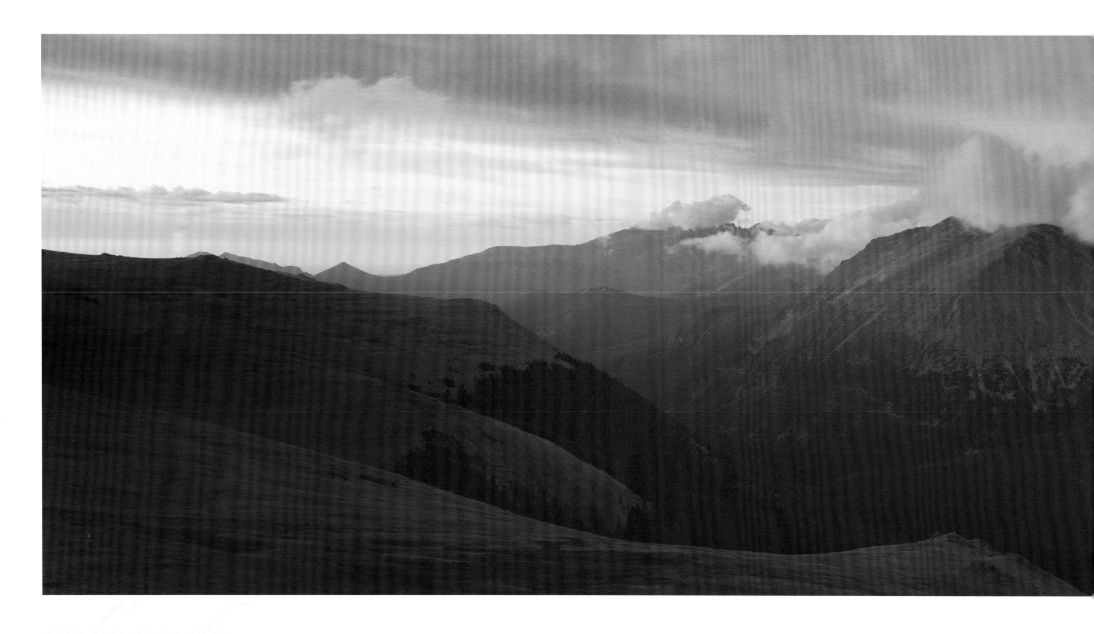

Health and hope for all who enter here, and, that once within the mellow-lighted and peaceful place, all would responsively hear the tree-tops whispering: 'These are your fountains and gardens of life; kindly assist in keeping them.'

- Enos Mills

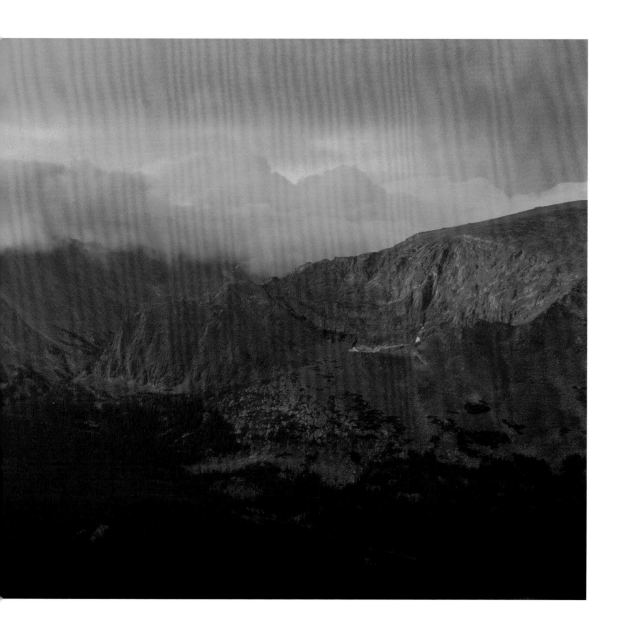

ROCKY MOUNTAIN

The park's rich scenery, typifying the massive grandeur of the Rocky Mountains, is accessible by Trail Ridge Road, which crosses the Continental Divide. Longs Peak, towering 14,259 feet, shadows wildlife and wildflowers in a landscape created by geologic uplift, glaciers and running water.

Chronology of Designations

1915 · Rocky Mountain National Park
1974 · Wilderness Area recommended (91%)
1976 · Biosphere Reserve

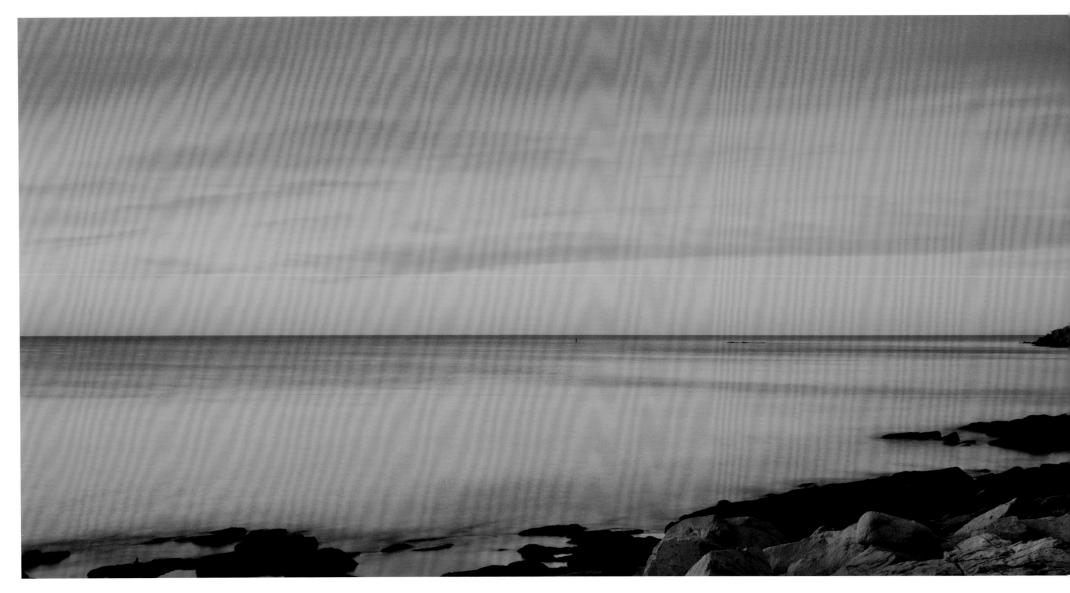

maine

Make the park what it should be, a sanctuary and protecting home for the whole region's plant and animal life... Make it this, and naturalists will seek it from the whole world over, and from it other men will learn to cherish similarly wild life in other places.

- George B. Dorr, 1916

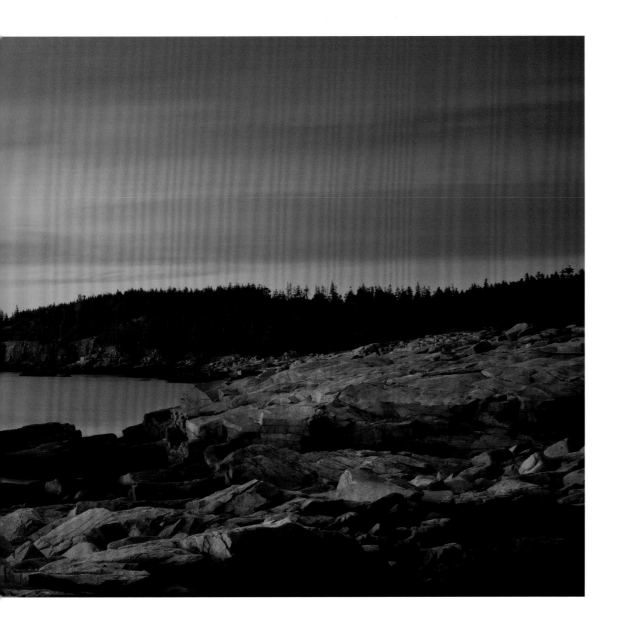

ACADIA

The sea sets the mood here, uniting the rugged coastal area of Mount Desert Island, picturesque Schoodic Peninsula on the mainland and the spectacular cliffs of Isle au Haut.

Chronology of Designations
1916 · Sieur de Monts National Monument
1919 · Lafayette National Park
1929 · Acadia National Park

47,400 acres

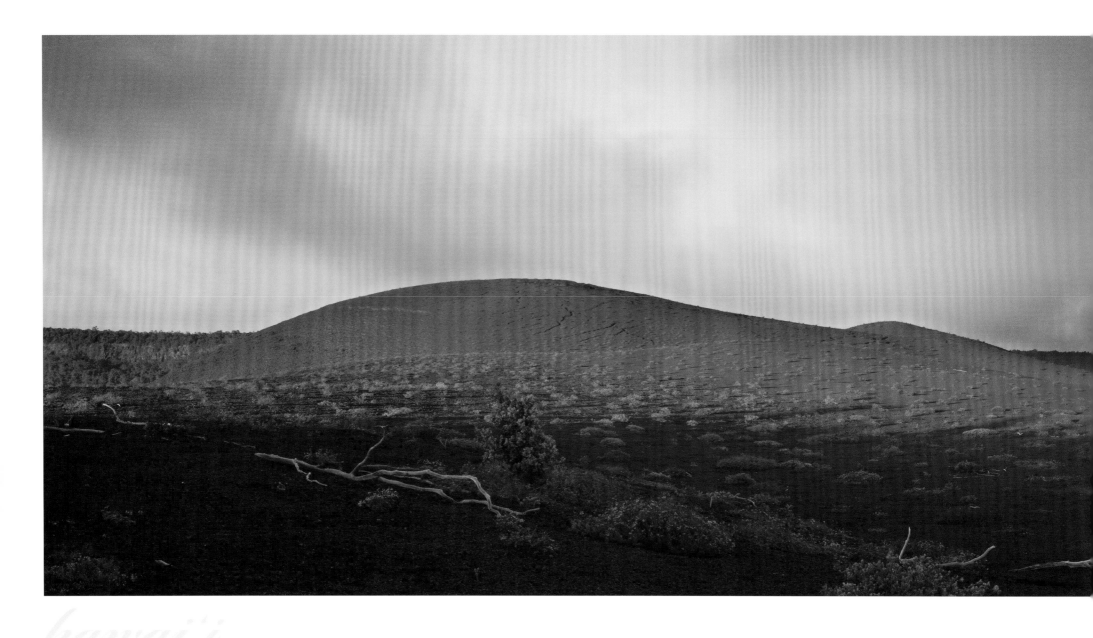

hawai'i

Pele, the sacred living deity of Hawai'i's volcanoes, controls the limitless power of creation through her perseverance, molten strength, and unearthly beauty. Her passion emanates from her ancient existence. Revered and honored is the fire goddess. She is my spiritual guardian and forever the heartbeat of my soul, continuously giving life to her land and its people.

- Pele Hanoa, Hawaiian elder on her birthday, 2004

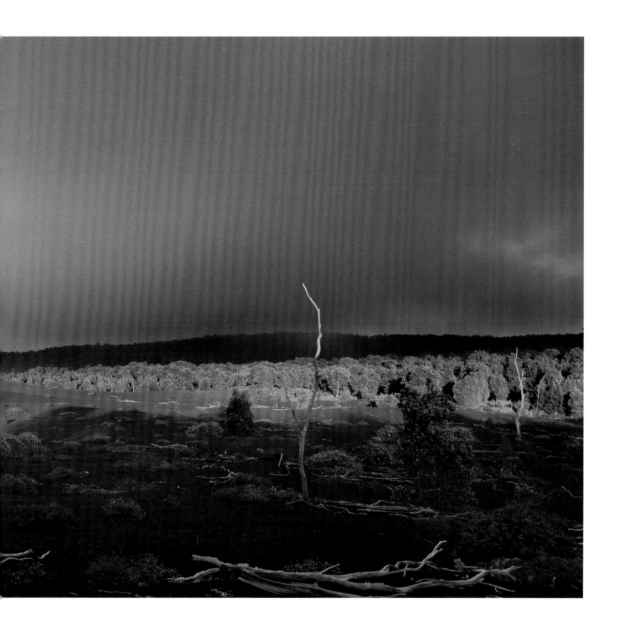

HAWAI'I VOLCANOES

Steam rises and lava flows in a park that encompasses two of the world's most active volcanoes, Kīlauea and Mauna Loa. Extending from sea level to 13,677', it is home to happyface spiders and carnivorous caterpillars, and a refuge for the endangered Hawai'ian goose, hoary bat, and hawksbill turtle. Here in this *wahi kapu*, sacred place, the beat of the drum and heartfelt expression of chant remind us that Hawai'i's indigenous culture is very much alive.

Chronology of Designations
- 1916 · Hawai'i National Park
- **1961 · Hawai'i Volcanoes National Park**
- 1978 · Wilderness Area (40%)
- 1980 · Biosphere Reserve
- 1987 · World Heritage Site

333,086 acres

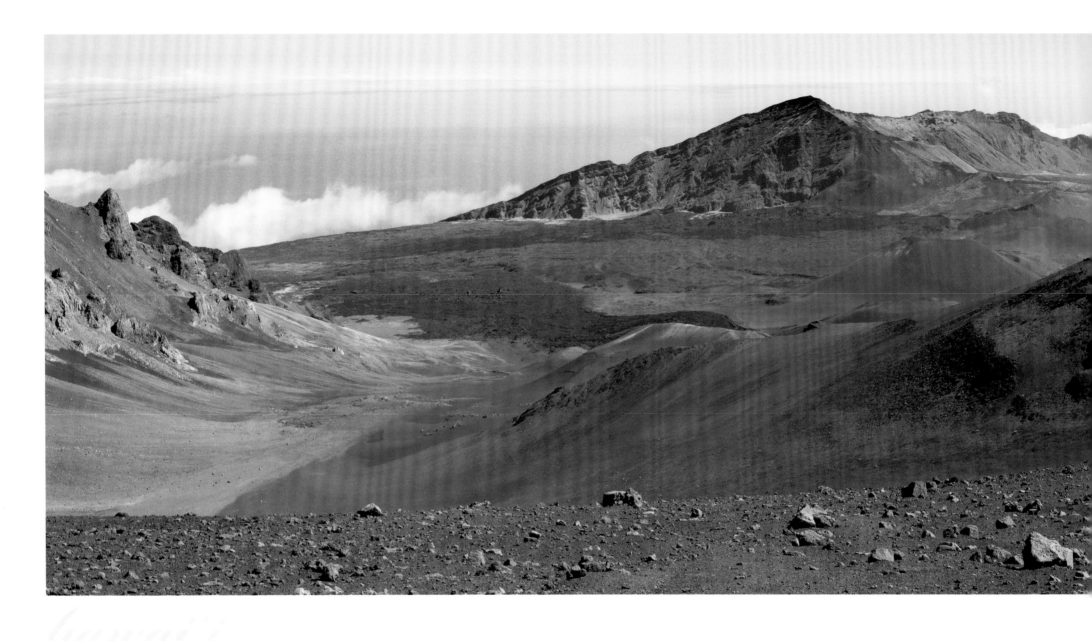

What a grand prospect! Standing on this lofty summit, ten thousand feet above the sea, a sight that beggars description bursts on the unprepared vision. Weariness is forgotten; language fails; silence reigns.

- Henry M. Whitney, on a trip to Haleakalā

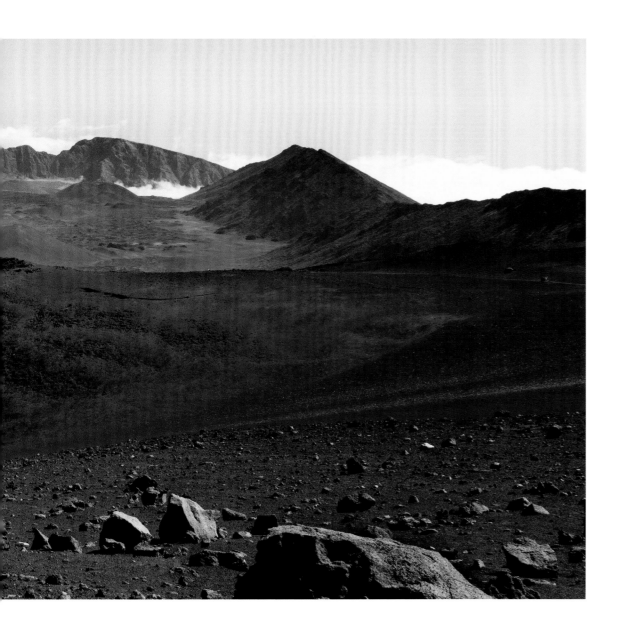

HALEAKALĀ

Fragile native Hawai'ian ecosystems, and the cultural connections to them, are protected in this park, which ranges from the mountain's summit to the ocean's edge on the island of Maui. The colorful floor of the crater is studded with cinder cones that are the place of legends and indicate the mountain's fiery history.

Chronology of Designations
1916 · Hawai'i National Park
1961 · Haleakalā National Park
1976 · Wilderness Area (84%)
1980 · Biosphere Reserve

30,058 acres

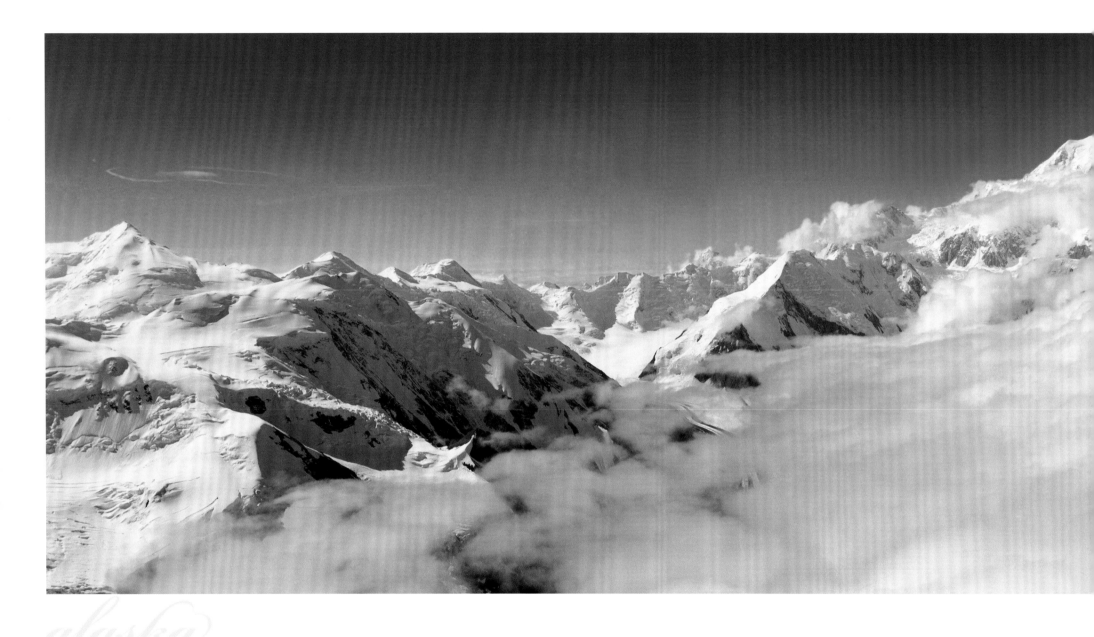

alaska

In the past (if not still today), it was considered disrespectful to talk about the size or majesty of a mountain while looking at it. A child doing this would be told, 'Don't talk; your mouth is small.' In other words, this was 'talking big,' disregarding the need to be humble before something so large as a mountain.

- Koyukon tradition, told by Richard K. Nelson, 1983

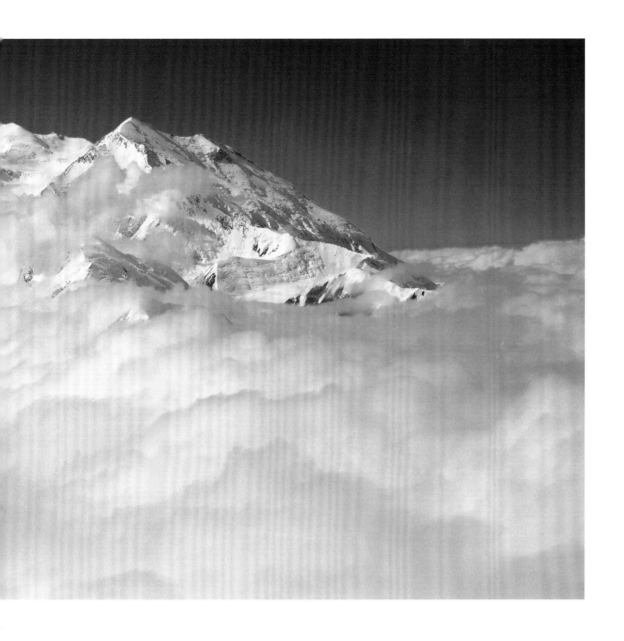

DENALI

The park is home to North America's highest mountain, 20,320-foot Mount McKinley. Large glaciers of the Alaska Range, caribou, Dall sheep, grizzly bears, moose, lynx and wolves are other highlights of this majestic landscape.

Chronology of Designations
1917 · Mount McKinley National Park
1976 · Biosphere Reserve
1978 · Denali National Monument
1980 · Denali National Park and Preserve
1980 · Wilderness Area (35%)

6,028,488 acres

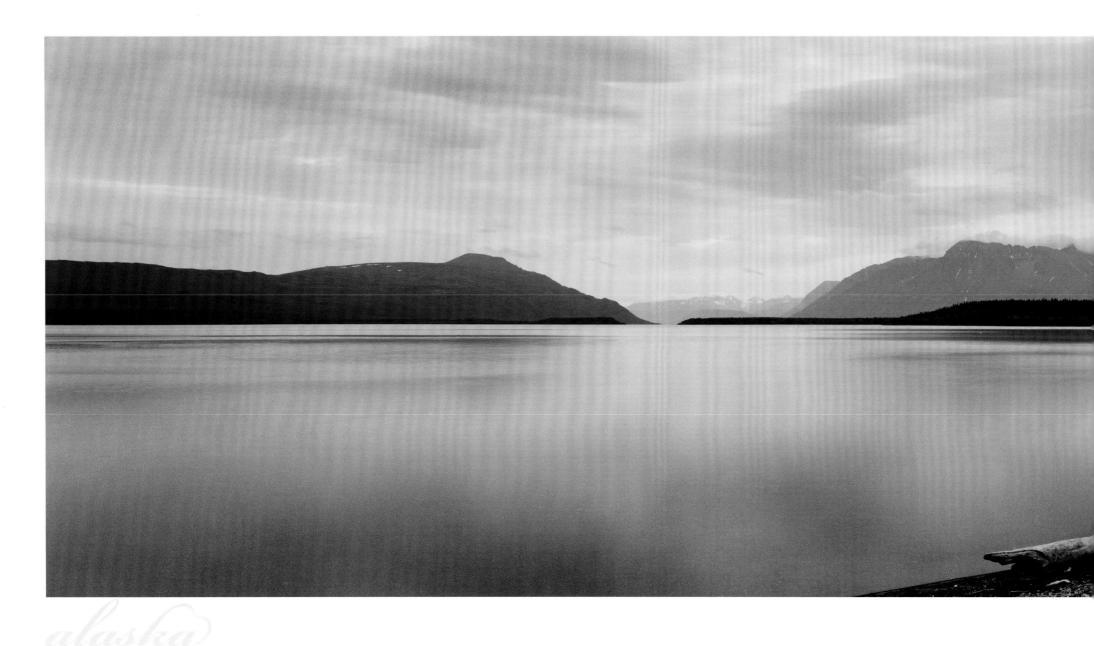

alaska

Pictures cannot bring back the Valley of the Smokes. They have lost the awesomeness that lies in the setting. You may build in memory, but never reproduce the scenes which lie beyond the Katmai Pass. They seem too big to be a part of the rest of the world. They do not connect up with the little things which are built into our lives.

- Donovan B. Church, 1917

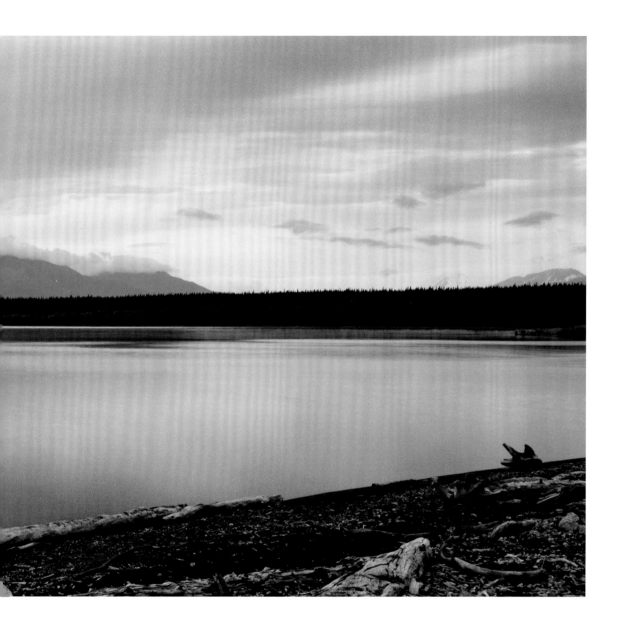

KATMAI

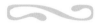

Variety marks this vast land; lakes, forests, mountains and marshlands all abound in wildlife. The Alaskan brown bear, the world's largest land carnivore, thrives here, feeding on red salmon that spawn in the many lakes and streams. Here, in 1912, Novarupta Volcano erupted violently, forming the ash-filled "Valley of Ten Thousand Smokes" where steam rose from countless fumaroles.

Chronology of Designations
1918 · Katmai National Monument
1980 · Katmai National Park and Preserve
1980 · Wilderness Area (82%)

4,124,075 acres

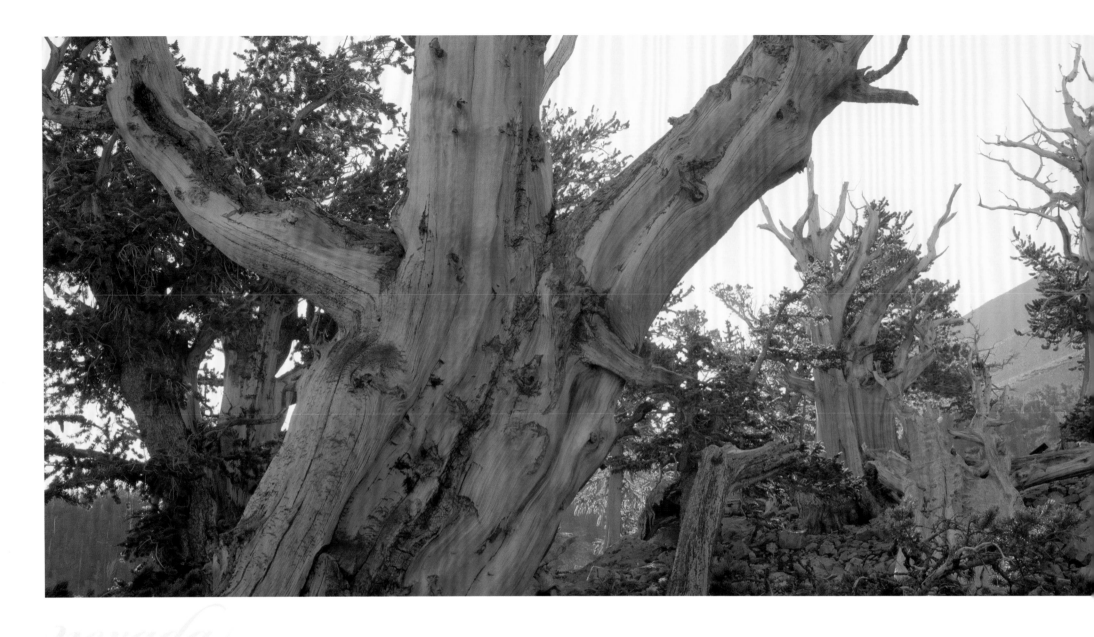

nevada

As the great ages of these trees and the beauty of both the trees and their environment
became known, visits to bristlecone pine localities took on the nature of pilgrimages.

- Charles W. Ferguson, 1968

GREAT BASIN

Lehman Caves National Monument, expanded to include the surrounding mountain and life zones of the Great Basin Desert, received its new designation as a national park in 1986. A remnant ice field on 13,063-foot Wheeler Peak, an ancient bristlecone pine forest, 75-foot limestone Lexington Arch and the tunnels and decorated galleries of Lehman Caves are the major features of the park.

Chronology of Designations
1922 · Lehman Caves National Monument
1986 · Great Basin National Park

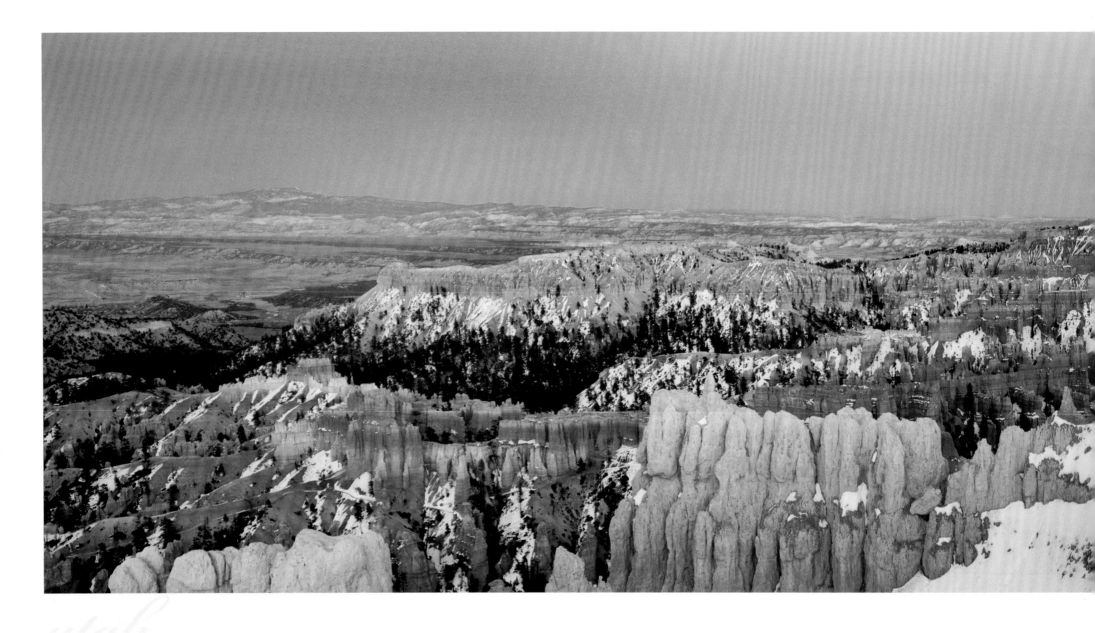

Before there were any Indians, the Legend People, To-when-an-ung-wa, lived in that place... They were of many kinds—birds, animals, lizards and such things—but they looked like people... For some reason the Legend People in that place were bad... Because they were bad, Coyote turned them all into rocks. You can see them in that place now, all turned into rocks; some standing in rows, some sitting down, some holding onto others. You can see their faces, with paint on them just as they were before they became rocks. The name of that place is Angka-ku-wass-a-wits. This is the story the people tell.

- Paiute Legend of Bryce Canyon, explained by Indian Dick

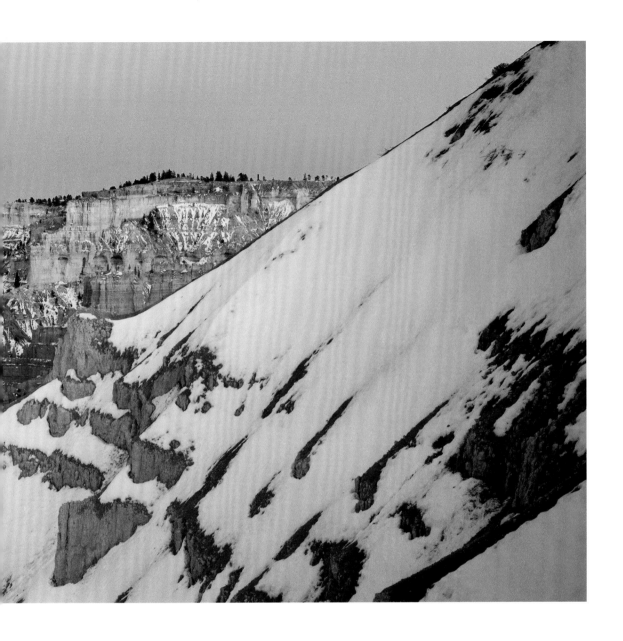

BRYCE CANYON

Innumerable, picturesque pinnacles, walls and spires stand in horseshoe-shaped amphitheaters along the edge of the Paunsaugunt Plateau in southwest Utah.

35,835 acres

Chronology of Designations
1923 · Bryce Canyon National Monument
1924 · Utah National Park
1928 · Bryce Canyon National Park
1978 · Wilderness Area proposed (58%)

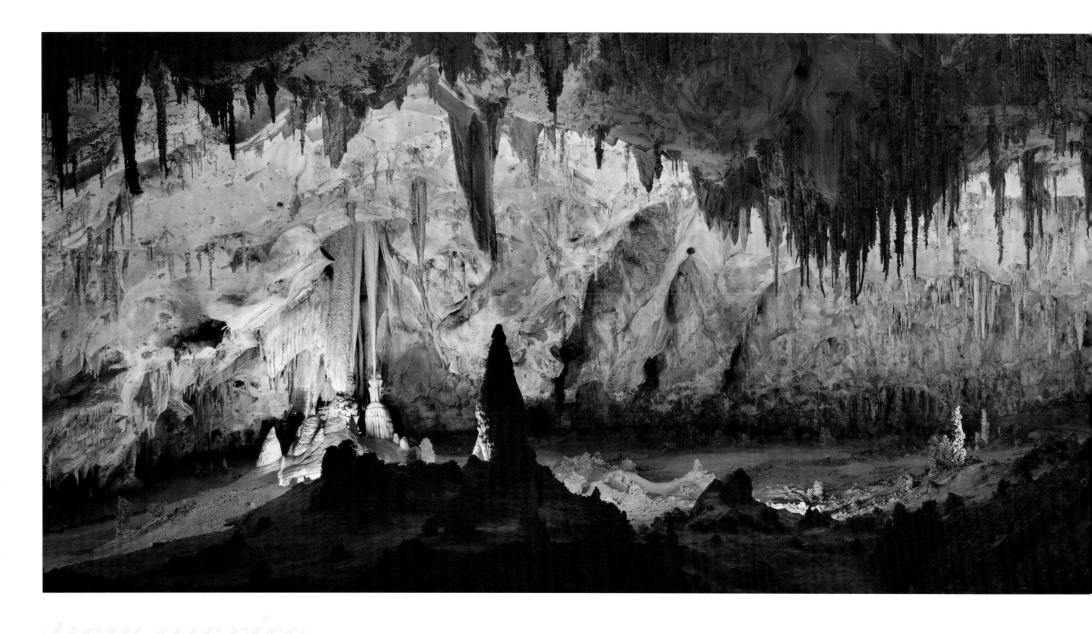

Carlsbad Cavern... is the most spectacular of underground wonders in America. For spacious chambers, for variety and beauty of multitudinous natural decorations, and for general scenic quality, it is king of its kind.

- Geologist Willis T. Lee, 1924

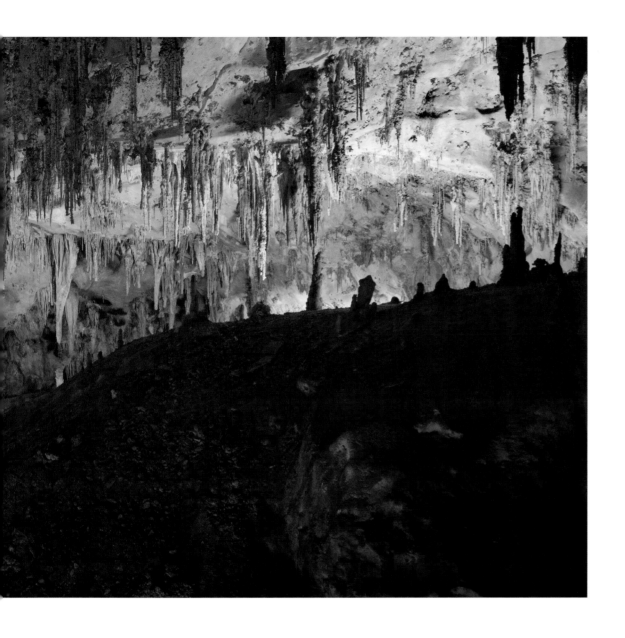

CARLSBAD CAVERNS

Carlsbad Cavern with its 30-plus miles of mapped passageways and large rooms, including the Big Room—one of the world's largest underground chambers—has countless formations and a world-famous colony of Mexican freetail bats. The park contains 113 known caves, including the nation's deepest limestone cave—1,567 feet—and fourth longest.

Chronology of Designations
1923 · Carlsbad Cave National Monument
1930 · Carlsbad Caverns National Park
1978 · Wilderness Area (70%)
1995 · World Heritage Site

46,766 acres

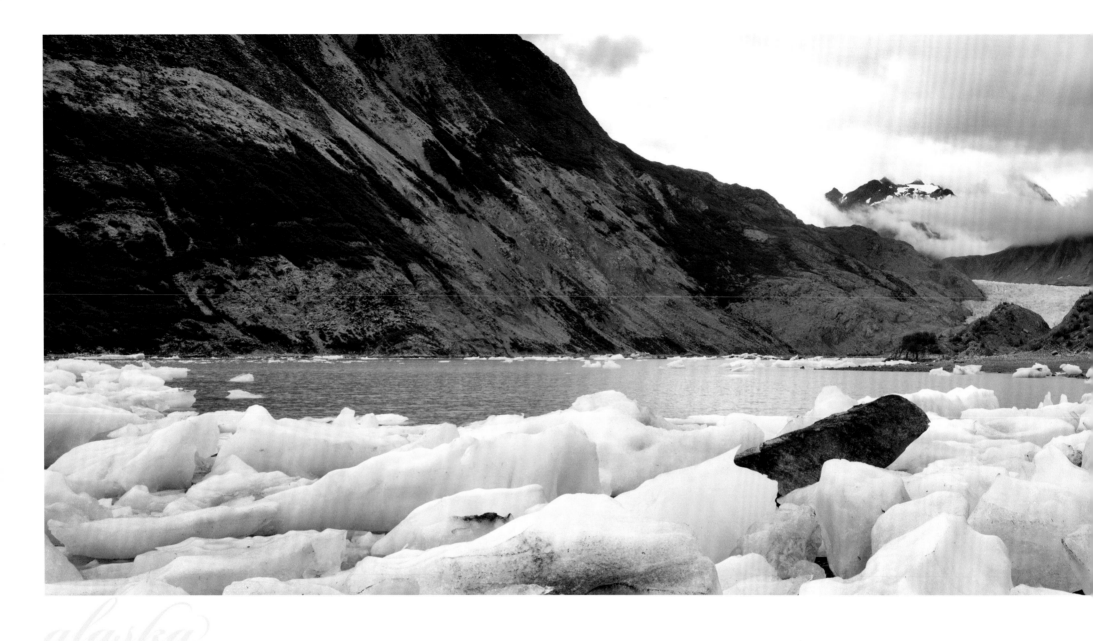

alaska

Words and dry figures can give one little idea of the grandeur of this glacial torrent flowing steadily and solidly into the sea, and the beauty of the fantastic ice front, shimmering with all the prismatic hues, is beyond imagery or description.

- Eliza Scidmore, Writer 1883

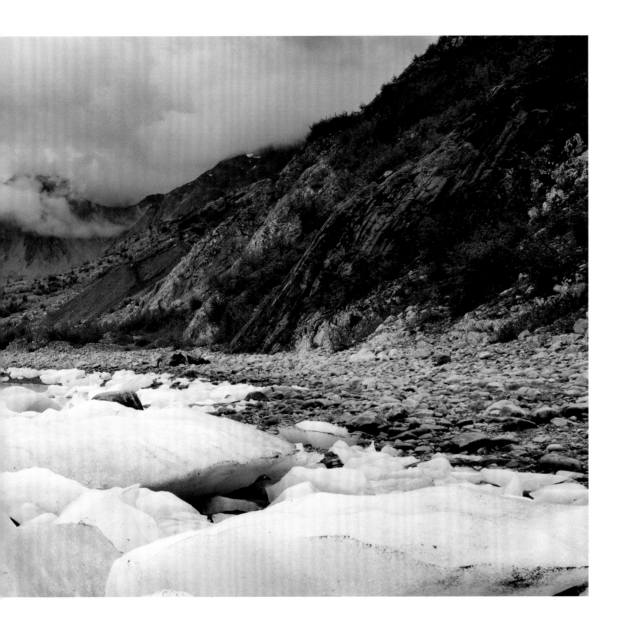

GLACIER BAY

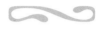

Great tidewater glaciers, a dramatic range of plant communities from rocky terrain recently covered by ice to lush temperate rain forest, and a large variety of animals, including brown bears, mountain goats, whales, seals and eagles, can be found in this grand landscape. This is the spiritual homeland of Hoonah Tlingit Indians.

Chronology of Designations
1925 · Glacier Bay National Monument
1980 · Glacier Bay National Park and Preserve
1980 · Wilderness Area (81%)
1986 · Biosphere Reserve
1992 · World Heritage Site

3,283,168 acres

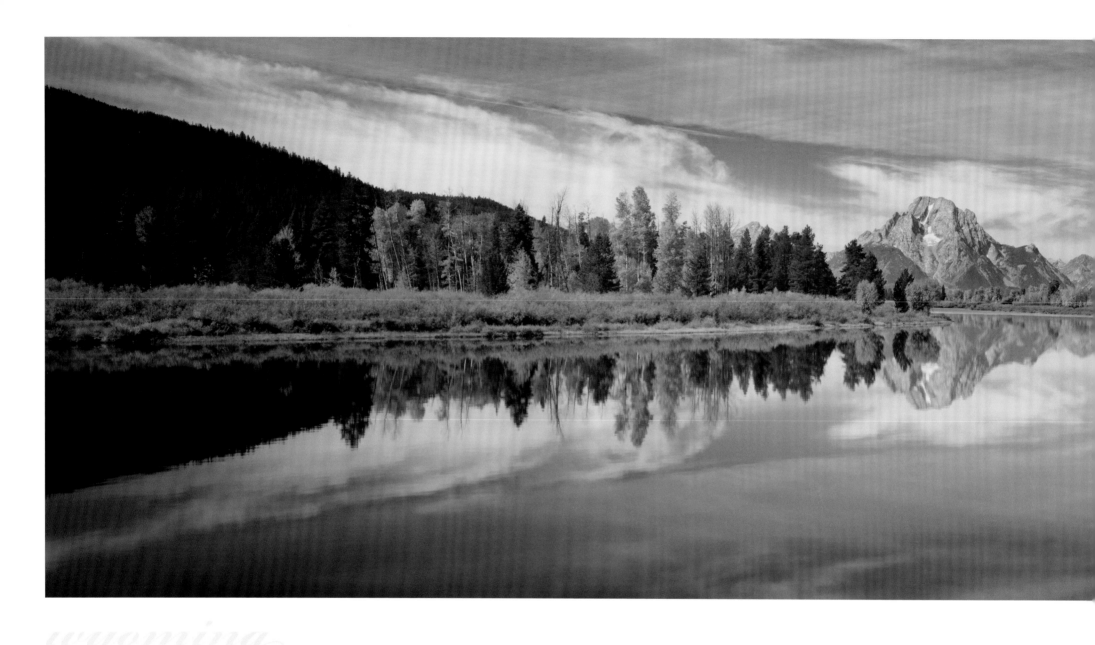

wyoming

The grand lift of the Tetons is more than a mechanistic fold and faulting of the earth's crust;
it becomes a primal gesture of the earth beneath a greater sky.

- Ansel Adams

GRAND TETON

Grand Teton features an awe-inspiring mountain range with numerous piedmont lakes nestled along its flanks and the broad, sagebrush-covered valley of Jackson Hole. In 1950, the park was expanded threefold by the incorporation of Jackson Hole National Monument (separately designated in 1943). The park is located in the heart of one of the largest intact temperate-zone ecosystems on earth—home to diverse wildlife such as moose, pronghorn antelope, elk and grizzly bears.

Chronology of Designations
1929 · Grand Teton National Park
1984 · Wilderness Area recommended (44%)

309,995 acres

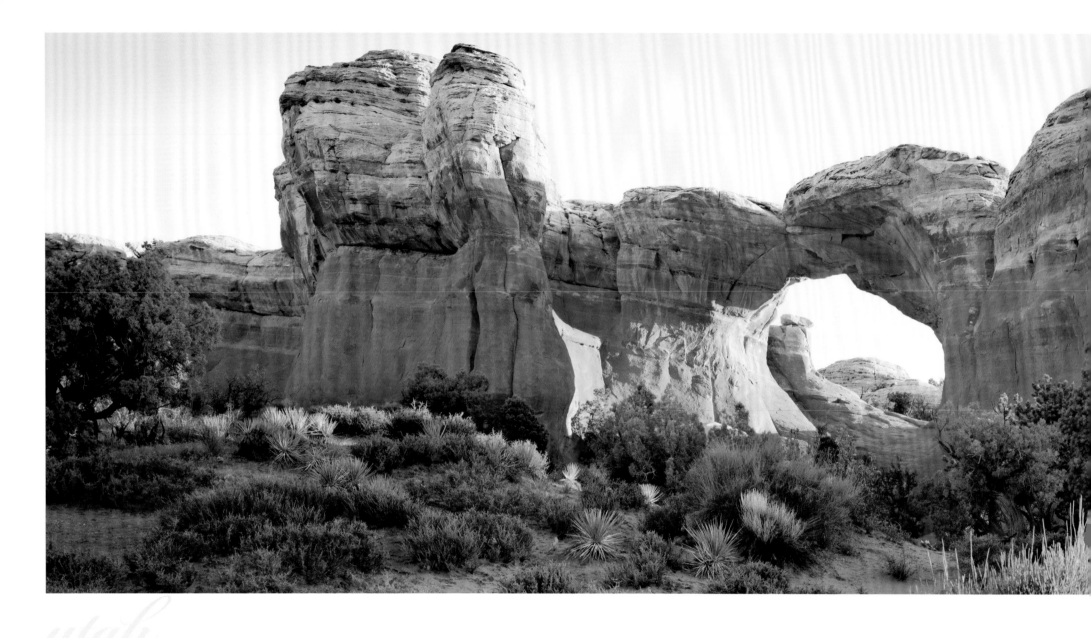

This is Coyote's country—a landscape of the imagination, where nothing is as it appears… Windows and arches ask you to recall what is no longer there, to taste the wind for the sandstone it carries. These astonishing formations invite a new mythology for desert goers, one that acknowledges the power of story and ritual.

- Terry Tempest Williams
Coyotes Canyon: A Collection of Native American Legends, 1989

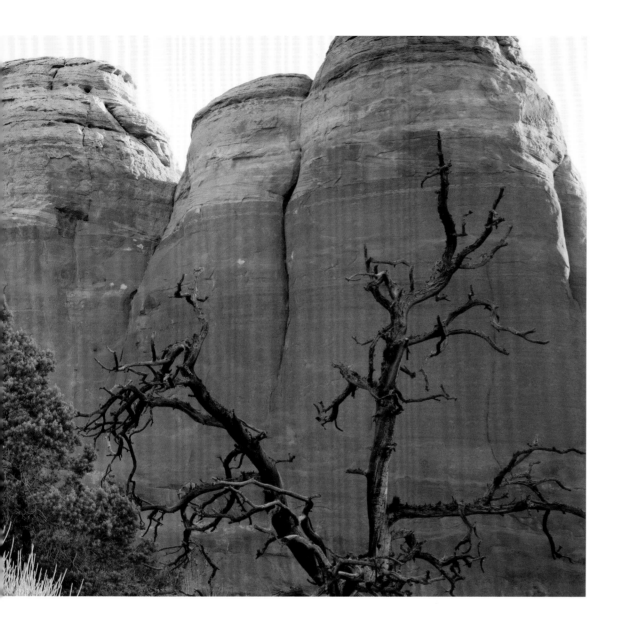

ARCHES

Millions of years of erosion have produced spectacular features in the form of some 2,000 arches, windows, pinnacles and pedestals.

Chronology of Designations
1929 · Arches National Monument
1971 · Arches National Park
1978 · Wilderness Area recommended (90%)

76,359 acres

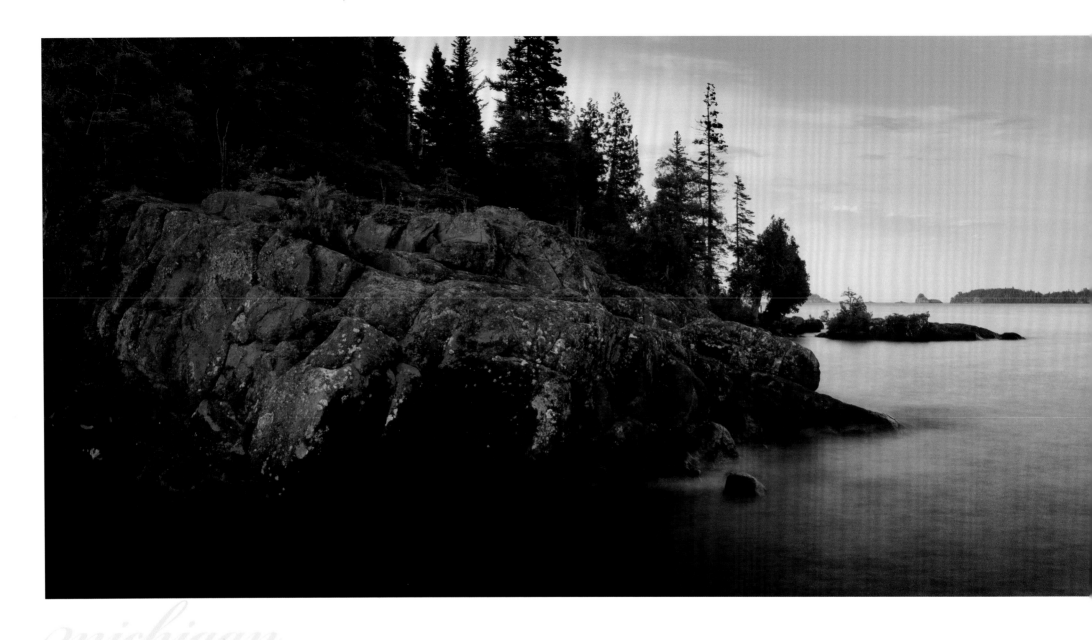

michigan

On this continent and in the world, Isle Royale is an almost unique repository of primitive conditions.
Like a priceless antique, it will be even more valuable in time not far ahead.

- Durward Allen, 1979

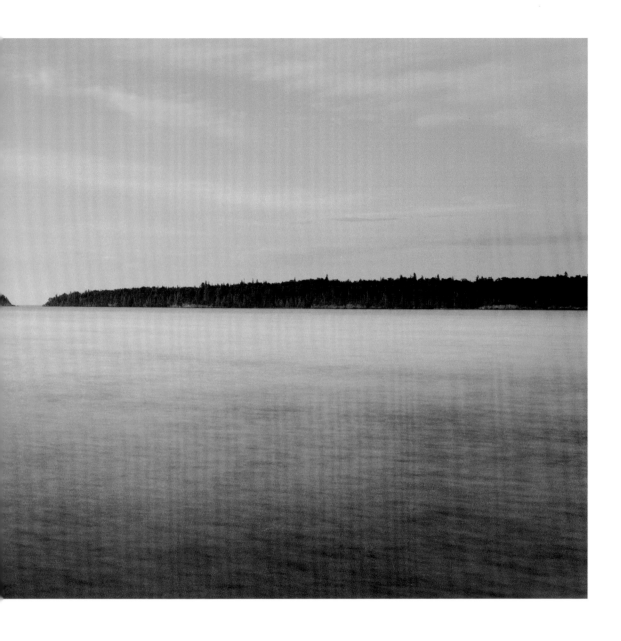

ISLE ROYALE

This wilderness island archipelago is distinguished by its maritime character, wolves, moose and pre-Columbian copper mines. The island is accessible only by boat or float plane. The park's 571,790 acres includes over 400,000 acres of Lake Superior waters.

Chronology of Designations
1931 · Isle Royale National Park
1976 · Wilderness Area (99% - land portion only)
1980 · Biosphere Reserve

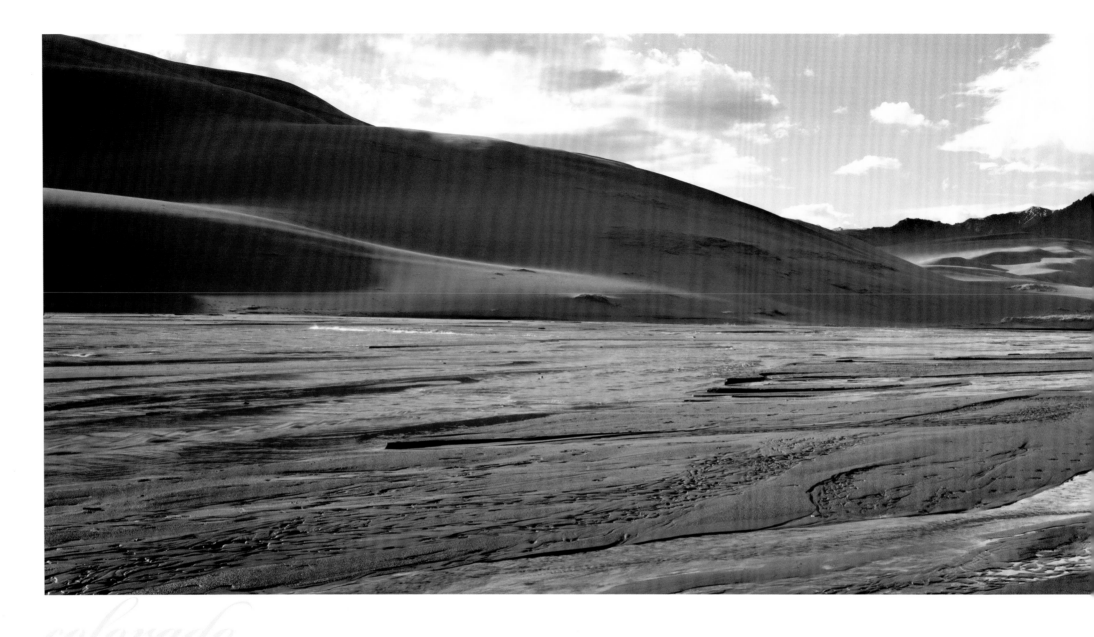

colorado

The dunes are as mystical and enigmatical as the Sphinx. They hold their own treasures,
keep their own counsel, only whispering out their secrets of a mighty past to the winds...

- Walsenburg Independent, 1946

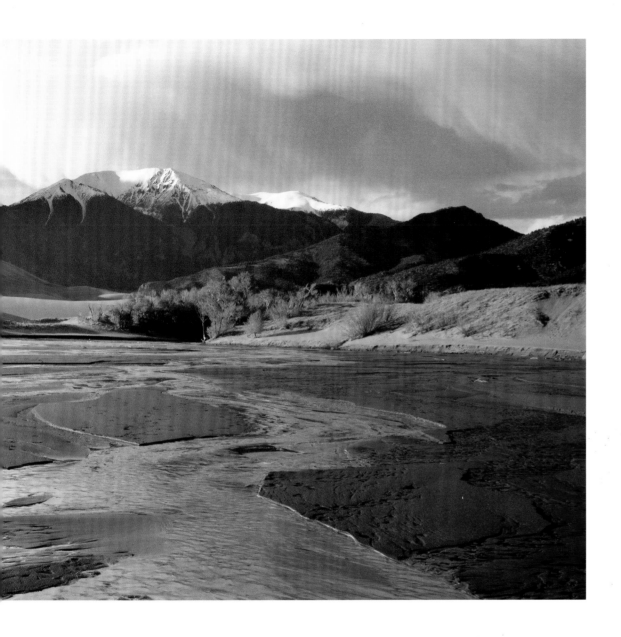

GREAT
SAND DUNES

These dunes, the tallest in North America, were deposited over thousands of years by winds blowing across San Luis Valley. The national park and preserve, which protects the entire surface watershed and high country components of the Great Sand Dunes system, ranges in elevation from 8,000 to more than 13,000 feet and includes life zones from desert to alpine tundra.

Chronology of Designations

1932 · Great Sand Dunes National Monument
1976 · Wilderness Area (51%)
2000 · Great Sand Dunes National Monument and Preserve
2004 · Great Sand Dunes National Park and Preserve

149,512 acres

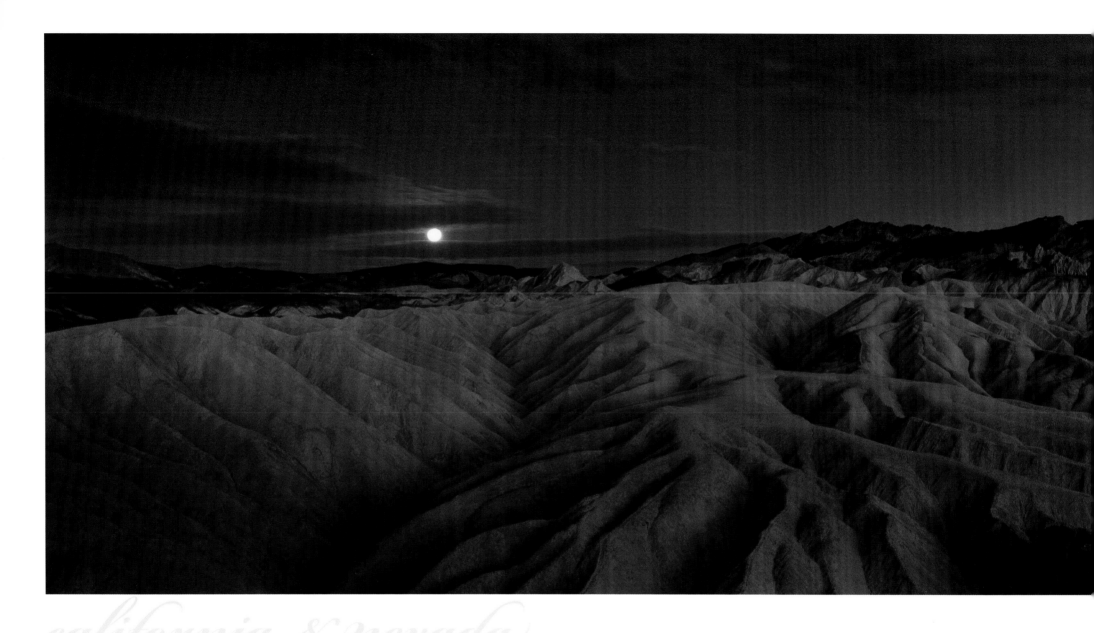

california & nevada

I believe in wilderness. I've always believed in the National Park Service to protect what's out there...
if it hadn't been for the National Park Service, where would we be at now and what would our homelands
look like... we feel that they've done the best they could with what they've got.

- Pauline Esteves, Timbisha Tribal Chair

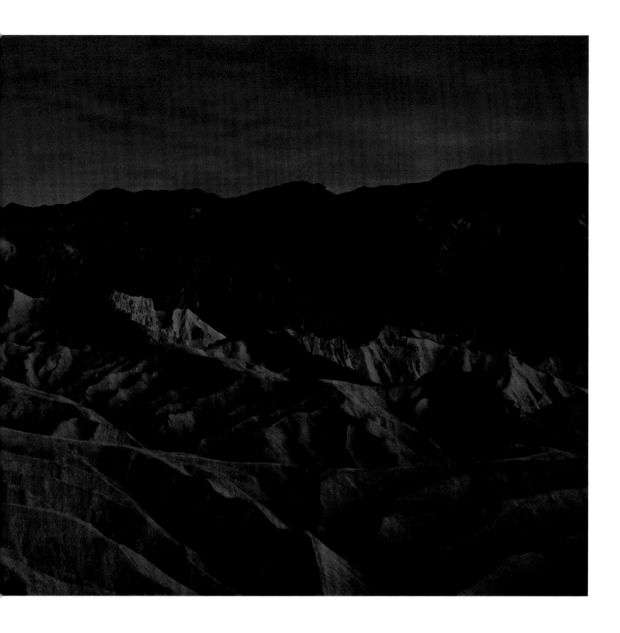

DEATH VALLEY

The largest national park in the continental United States, Death Valley has grand vistas surrounded by high mountains. The valley is a land of extremes, containing one of the hottest places on Earth and driest and lowest places in North America. The area also includes Scotty's Castle, made famous by an outspoken and flamboyant prospector named Walter Scott, as well as remnants of gold and borax mining.

Chronology of Designations
1933 · Death Valley National Monument
1984 · Biosphere Reserve
1994 · Death Valley National Park
1994 · Wilderness Area (96%)

3,372,402 acres

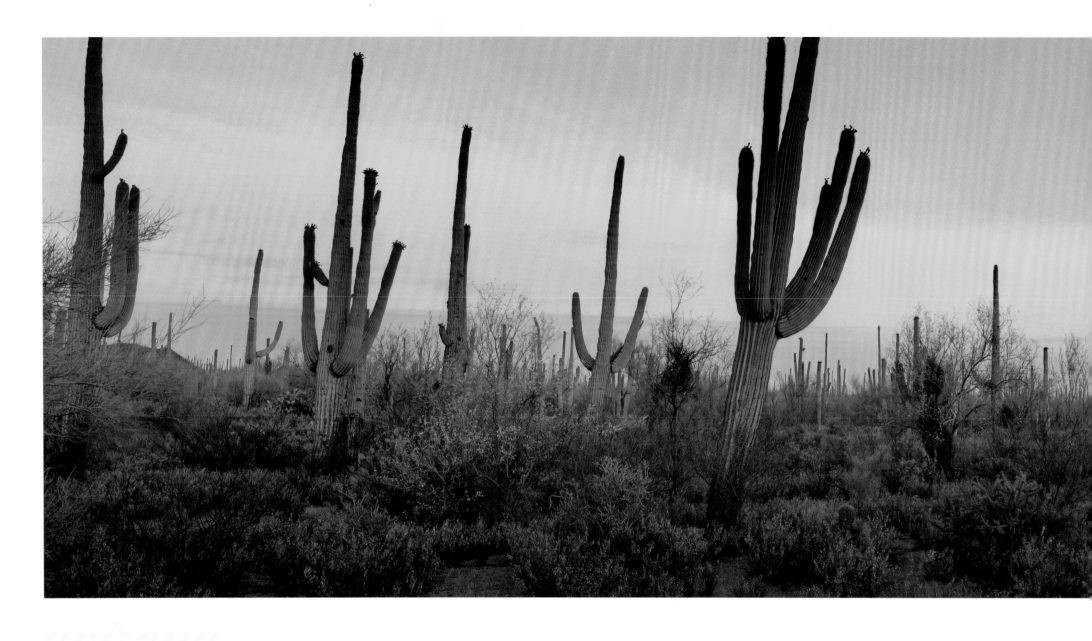

We as O'odham people know that we have to respect this earth that we walk upon because we as O'odham people were made from this earth and when we pass away we go back to the earth so the way that you treat the earth, when you understand that our relatives are back into this earth, so if you throw trash on this earth, you are throwing trash on your relative, your hahajuni.

- Daniel L. Preston, Jr.
Native American consultant for cultural resources

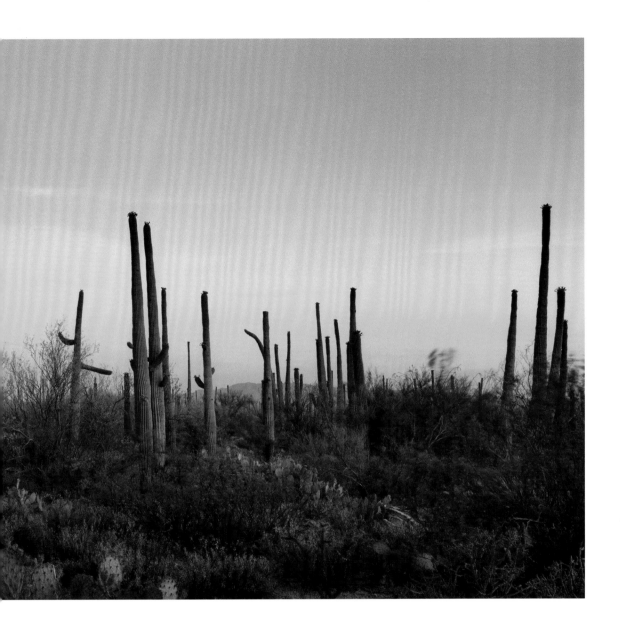

SAGUARO

Giant Saguaro cacti—often reaching 30 feet in height and unique to the Sonoran Desert—cover the valley floor and rise into the neighboring mountains. Five biotic life zones are represented here, from desert to ponderosa pine forest. There are also ancient petroglyphs.

Chronology of Designations
1933 · Saguaro National Monument
1976 · Wilderness Area (77%)
1994 · Saguaro National Park

91,440 acres

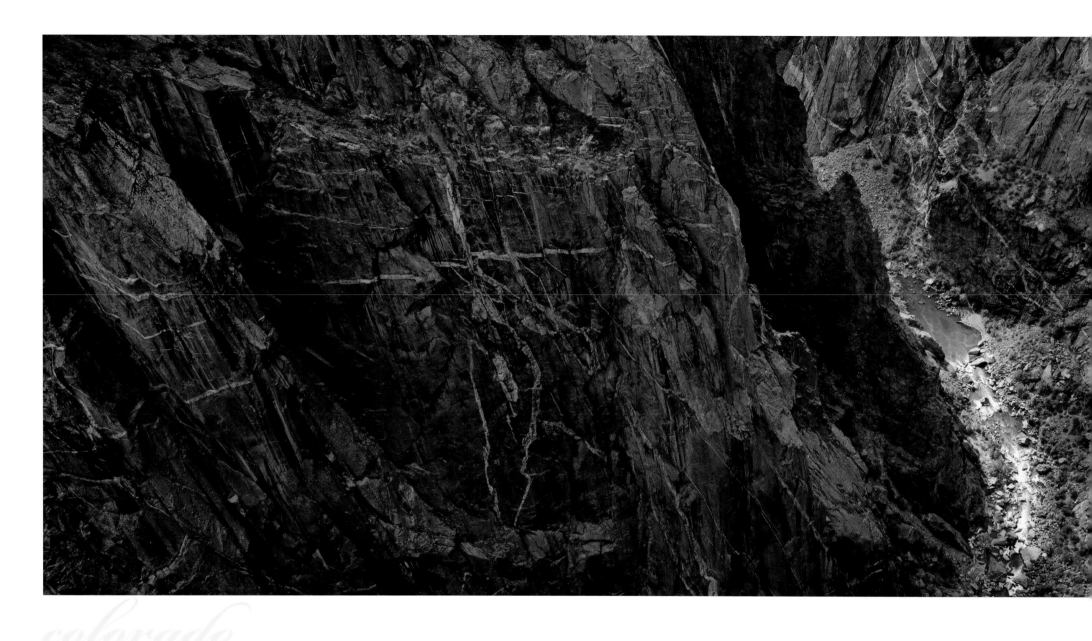

Hereto was unfolded view after view of the most wonderful, the most thrilling of rock exposures, one vanishing from view only to be replaced by another still more imposing. A view which could easily be made into a Scottish Feudal Castle would be followed by another suggesting the wildest parts of Australia, and this by one representing a New York skyscraper of the most imposing height and majestic proportions.

- Harvey C. Wright

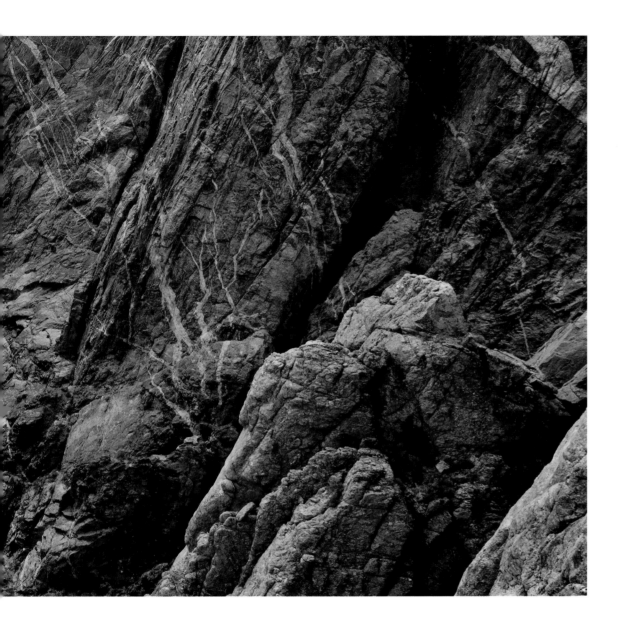

BLACK CANYON OF THE GUNNISON

The ancient Gunnison River was wedged here by volcanic deposits and committed to a course from which it could not escape. Monolithic rock walls rise 2,000 feet above the river. No other canyon in North America combines the narrow opening, sheer walls and startling depths offered by the Black Canyon of the Gunnison.

Chronology of Designations

1933 · Black Canyon of the Gunnison
 National Monument

1976 · Wilderness Area (51%)

**1999 · Black Canyon of the Gunnison
 National Park**

32,950 acres

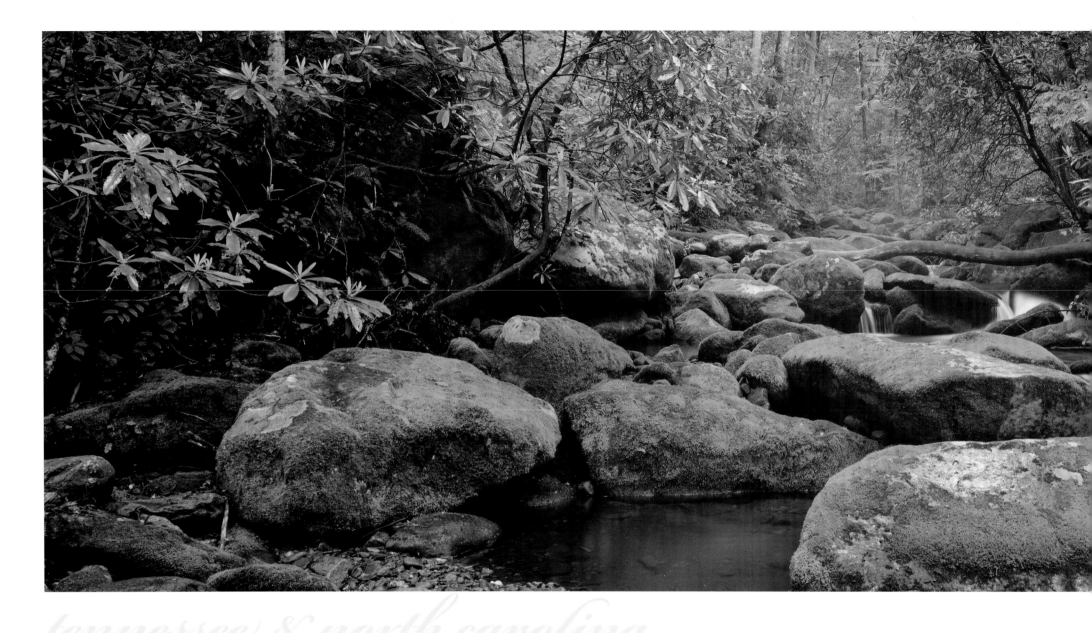

The Great Smoky Mountains are a sanctuary for the Cherokee people. We have always believed the mountains and streams provide all that we need for survival. We hold these mountains sacred, believing that the Cherokees were chosen to take care of the mountains as the mountains take care of us.

- Jerry Wolfe, Cherokee Elder, 2000

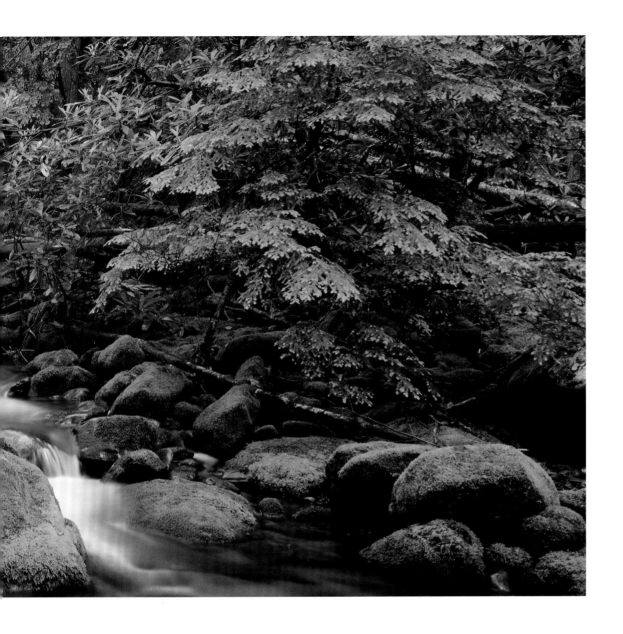

GREAT SMOKY MOUNTAINS

Here, sixteen mountain peaks rise over 6,000 feet in elevation. This park is the largest federally protected mountain ecosystem east of the Rocky Mountains and preserves the greatest diversity of life in the temperate regions of the United States, an estimated 100,000 species. The park also contains an impressive number of 19th-century log and frame buildings, architectural remnants of southern mountain culture.

Chronology of Designations

1934 · **Great Smoky Mountains National Park**
1974 · Wilderness Area recommended (88%)
1976 · Biosphere Reserve
1983 · World Heritage Site

521,495 acres

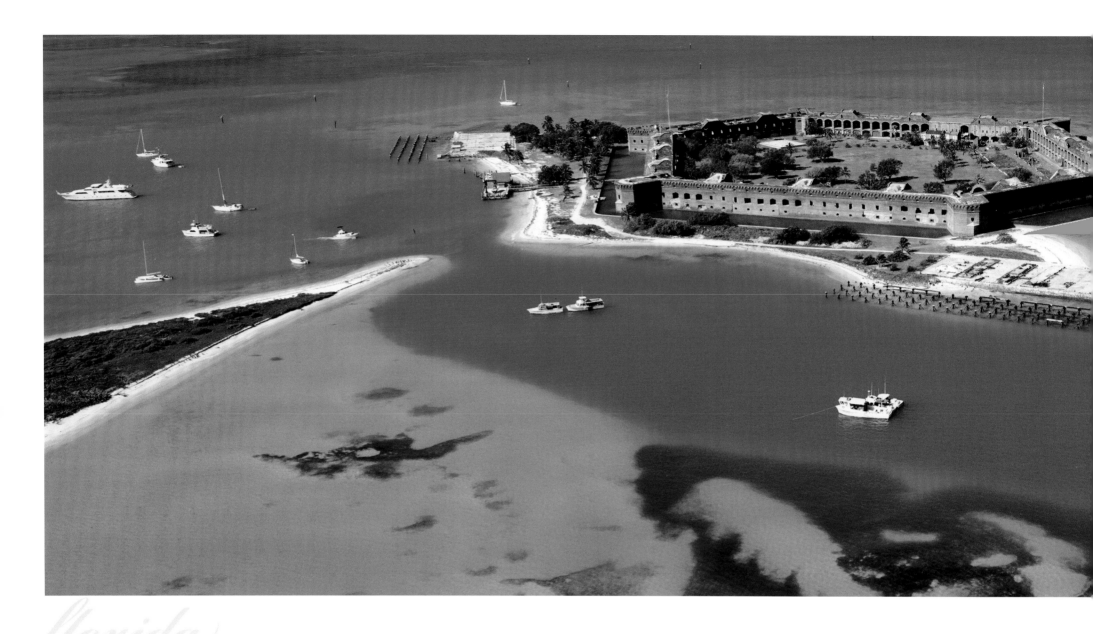

florida

I felt as if the birds would raise me from the ground, so thick were they all around, and so quick the motion of their wings; their cries were indeed deafening… cloud-like masses fly up… in swarms like those of bees in their hives.

- John James Audubon
on a visit to Dry Tortugas in 1832

DRY TORTUGAS

Fort Jefferson was built between 1846 and 1866 to help control the Florida Straits. It is the largest all-masonry fortification in the western world. This remote marine wilderness located at the extreme western tip of the Florida Keys contains abundant bird and marine life, coral reefs and remnants of seafaring days.

Chronology of Designations
1935 · Fort Jefferson National Monument
1992 · Dry Tortugas National Park

64,701 acres

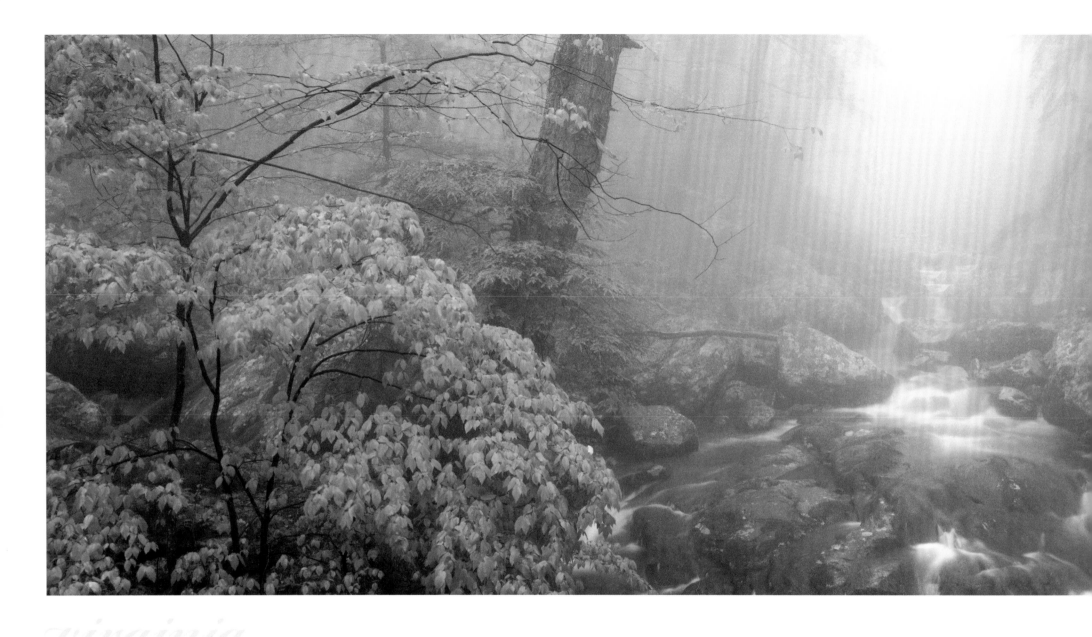

virginia

This park... is in the largest sense a work of conservation... we are preserving the beauty and the wealth of the hills, and the mountains and the plains and the trees and the streams... We seek to pass on to our children a richer land—a stronger nation. I, therefore, dedicate Shenandoah National Park to this and succeeding generations of Americans for the recreation and for the re-creation which we shall find here.

- President Franklin D. Roosevelt

SHENANDOAH

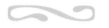

Scenic Skyline Drive, on the National Register of Historic Places, winds along the crest of the Blue Ridge Mountains of Virginia for 105 miles. The park, which includes 300-square-miles of the southern Appalachians, offers not only the area's most scenic roadway, but hiking trails (including a segment of the over 2,000-mile Appalachian Trail), diverse wildlife and an ever-changing hardwood forest.

Chronology of Designations
1935 · Shenandoah National Park
1976 · Wilderness Area (40%)

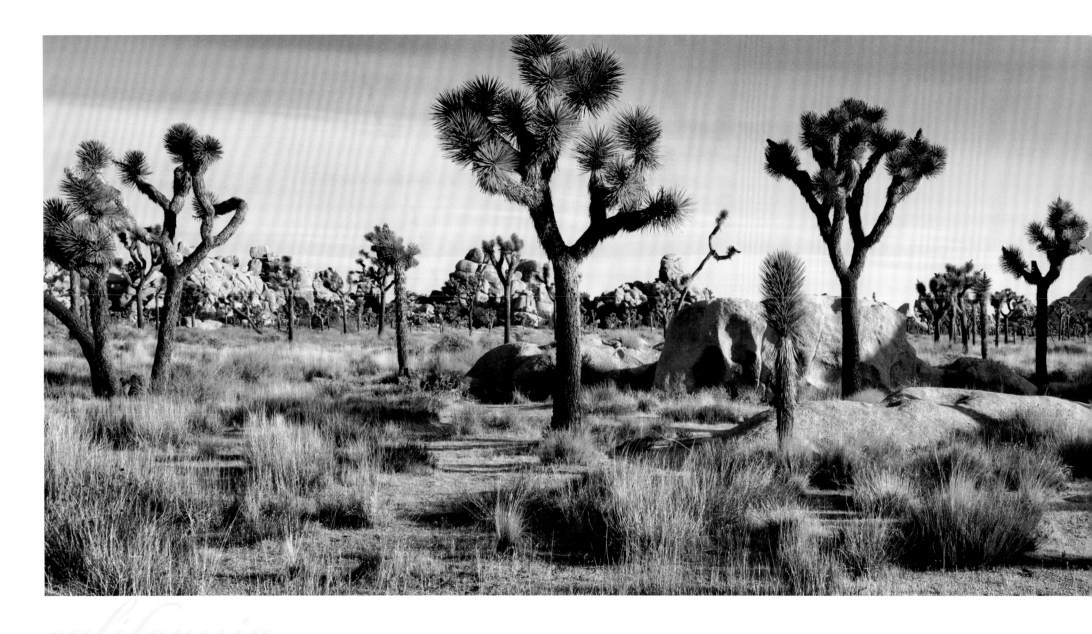

california

[The Serrano] came to the oasis because a medicine man told them it was a good place to live and that they would have many boy babies. The medicine man instructed them to plant a palm tree each time a boy was born. In the first year, the Serrano planted 29 palm trees at the oasis. The palms also provided the Serrano with food, clothing, cooking implements and housing.

- **Legend of the Oasis of Mara**

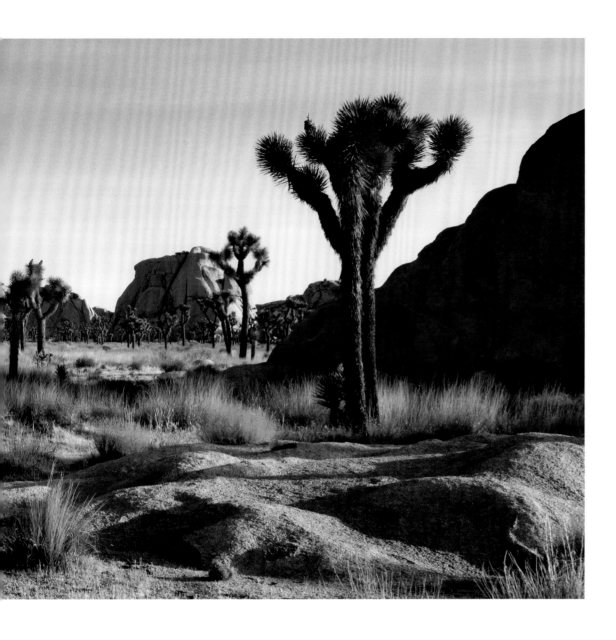

JOSHUA TREE

An outstanding representative stand of Joshua trees and a great variety of other Mojave and Colorado Desert plants and animals exist in this starkly beautiful, high-desert country of southern California.

Chronology of Designations
1936 · Joshua Tree National Monument
1976 · Wilderness Area (74%)
1984 · Biosphere Reserve
1994 · Joshua Tree National Park

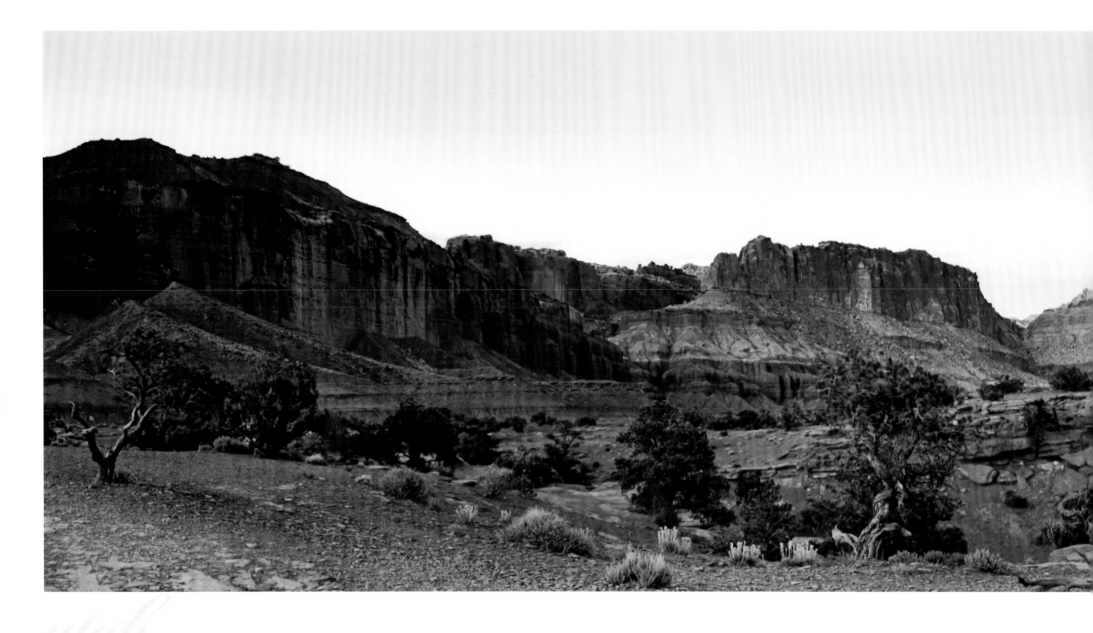

Stretching away as far as the Eye can see a naked barren plain of red and white Sandstone crossed in all directions by innumerable gorges... high buttes rising above the general level, the country gradually rising up to the ridges marking the 'breakers' or rocky bluffs of the larger streams [*sic*]. The Sun shining down on this vast plain almost dazzled our eyes by the reflection as it was thrown back from the fiery surface...

- Adjutant Franklin B. Woolley, 1866

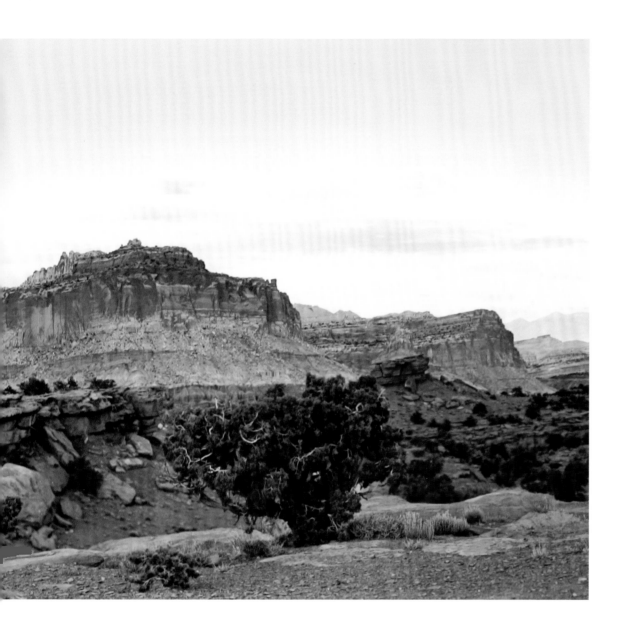

CAPITOL REEF

The 100-mile long Waterpocket Fold, an uplift of sandstone cliffs with highly colored sedimentary layers, defines this geologic paradise. The Fold is very steep on one side in an area of horizontal rock layers. Dome-shaped white cap rock, resembling a capitol building, account for the park's name. Preserved also is rock art of the Fremont culture and an historic Mormon settlement.

Chronology of Designations
1937 · Capitol Reef National Monument
1971 · Capitol Reef National Park
1977 · Wilderness Area recommended (74%)

241,904 acres

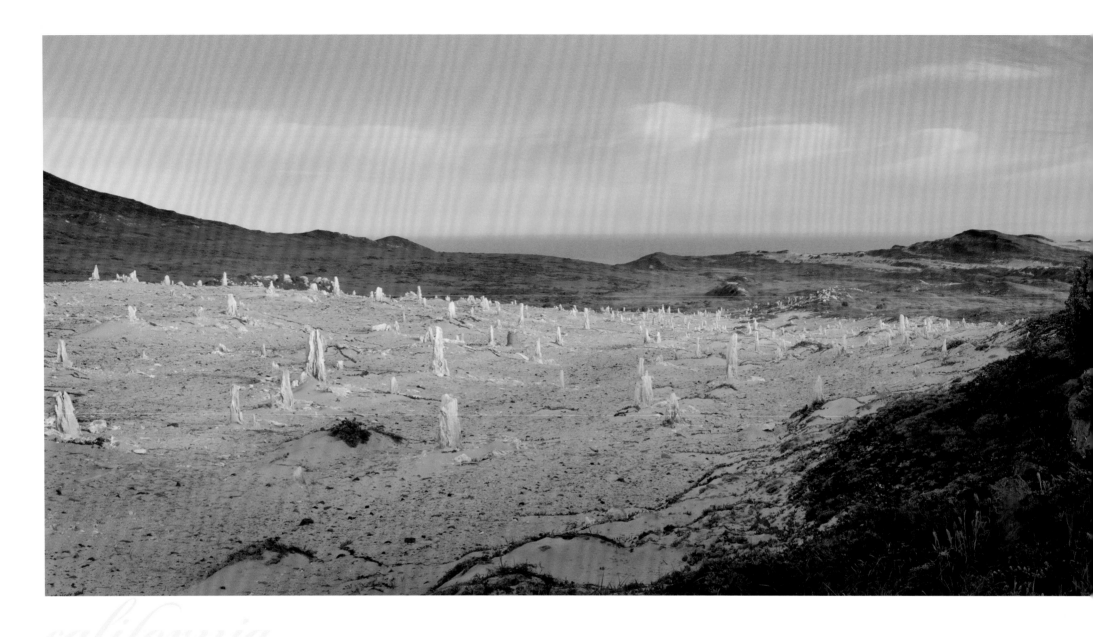

We were going home. Invisible songlines and storytrails charted our way across the ocean towards Limuw, Santa Cruz Island.
Dolphin people, 'alolk'oy, ancient relatives, led the way, jumping out of the water and rising toward the morning sun.

- Georgiana Valoyce Sanchez, Chumash

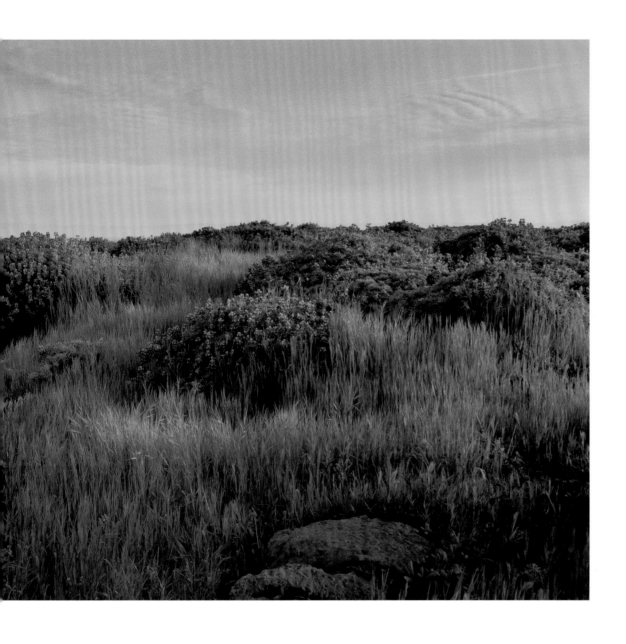

CHANNEL ISLANDS

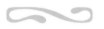

This park consists of five islands off Southern California and is the home of nesting seabirds, sea lion rookeries and unique plants. One hundred and forty-five species are found nowhere else in the world. The waters contain a multitude of marine organisms ranging from microscopic plankton to the world's largest whale, the blue whale.

Chronology of Designations
1938 · Channel Islands National Monument
1976 · Biosphere Reserve
1980 · Channel Islands National Park

249,561 acres

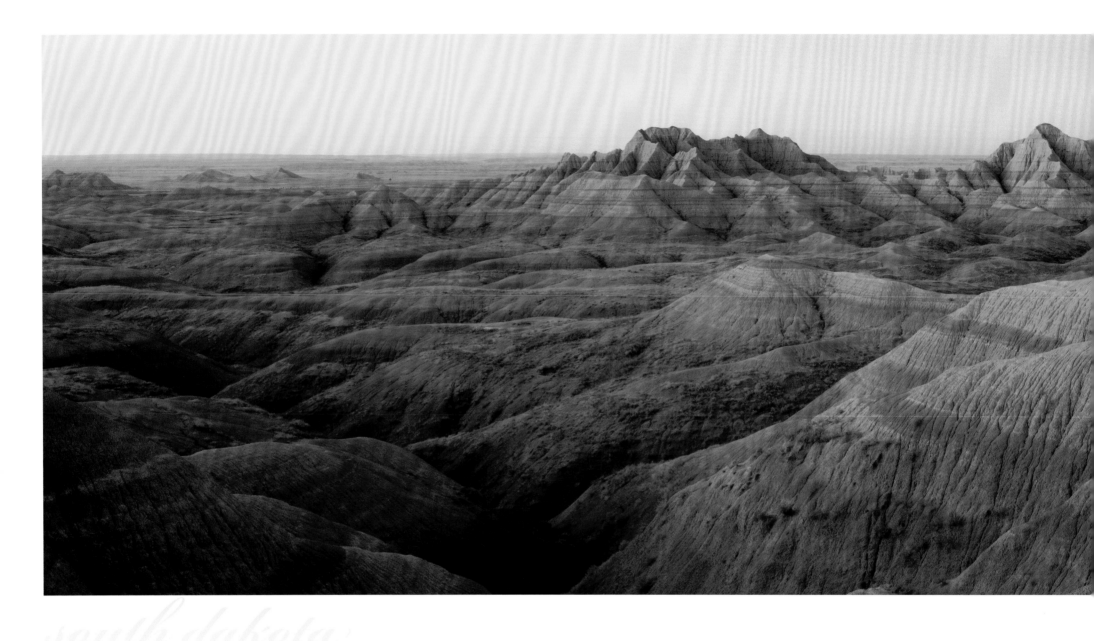

south dakota

At first as one looks over the strange landscape there may come a feeling of the incongruous or grotesque but studying more closely the meaning of every feature of the spirit of this marvelous handiwork of the Great Creator develops and vistas of beauty appear.

- C. C. O'Harra, 1920

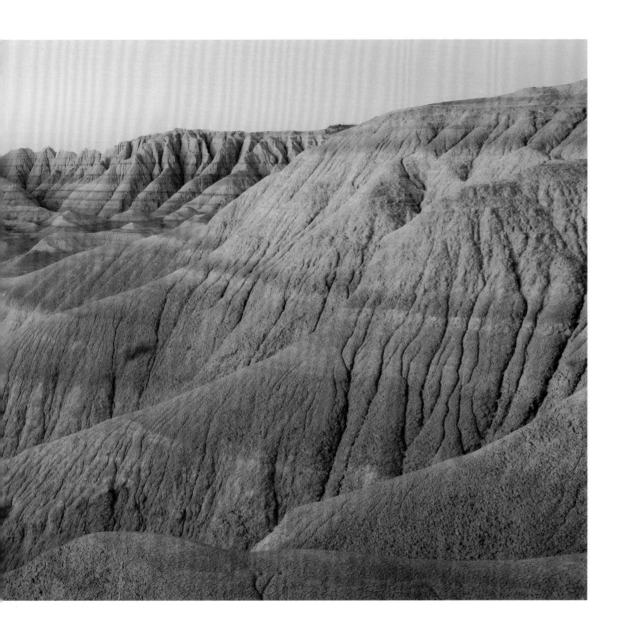

BADLANDS

Carved by erosion, this scenic landscape contains mammal fossils from 26 to 37 million years ago. Prairie grasslands support bison, bighorn sheep, deer, pronghorn antelope, swift fox and black-footed ferrets.

Chronology of Designations
1939 · Badlands National Monument
1976 · Wilderness Area (26%)
1978 · Badlands National Park

242,756 acres

kentucky

I spent a long summer day in exploring the Mammoth Cave in Kentucky. We traversed the six or eight black miles from the mouth of the cavern to the innermost recess which tourists visit... We shot Bengal lights into the vaults and groins of the sparry cathedrals, and examined all the masterpieces which the four combined engineers, water, limestone, gravitation and time, could make in the dark.

- Ralph Waldo Emerson, 1856

MAMMOTH CAVE

This park was established to preserve an extensive cave ecosystem, including Mammoth Cave, the scenic river valleys of the Green and Nolin Rivers, and a section of hill country of south central Kentucky. This is the longest known cave system in the world, with more than 350 miles explored and mapped.

Chronology of Designations
1941 · Mammoth Cave National Park
1981 · World Heritage Site
1990 · Biosphere Reserve

52,830 acres

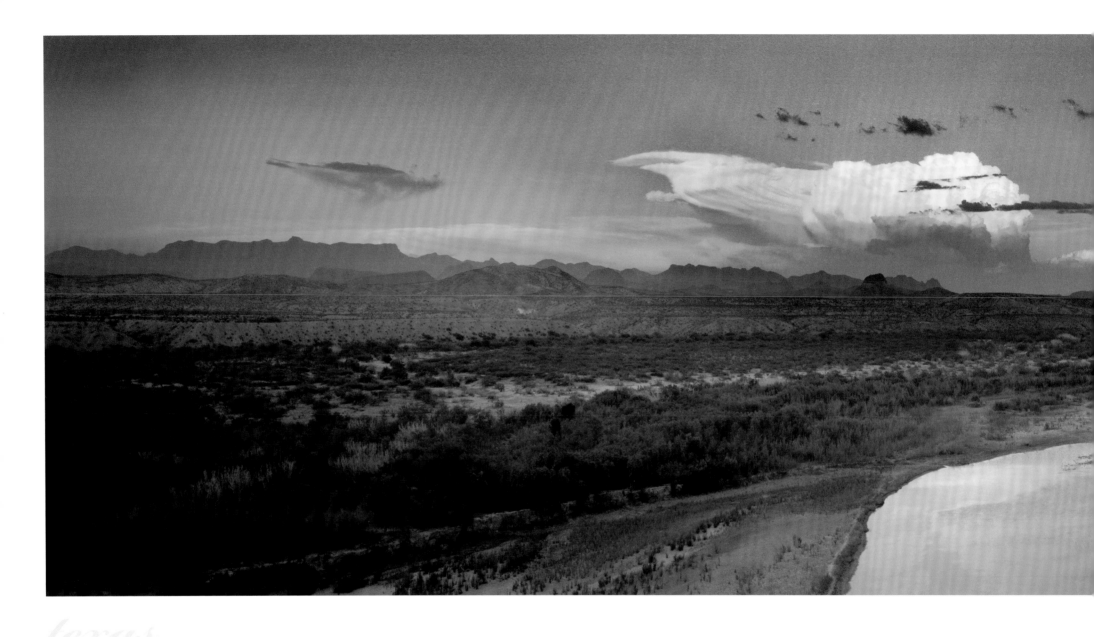

I'd rather be broke down and lost in the wilds of Big Bend, any day, than wake up some morning in a penthouse suite high above the megalomania of Dallas or Houston.

- Edward Abbey, "Big Bend"

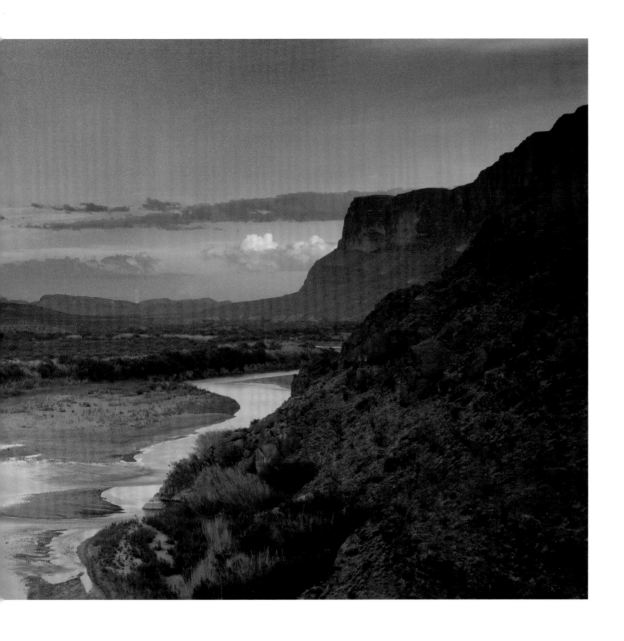

BIG BEND

Mountains contrast with desert within this great bend of the Rio Grande River, which serves as the boundary between the United States and Mexico, as the river waters rush through deep-cut canyons and open desert for 118 miles.

Chronology of Designations
1944 · **Big Bend National Park**
1984 · Wilderness Area recommended (67%)

801,163 acres

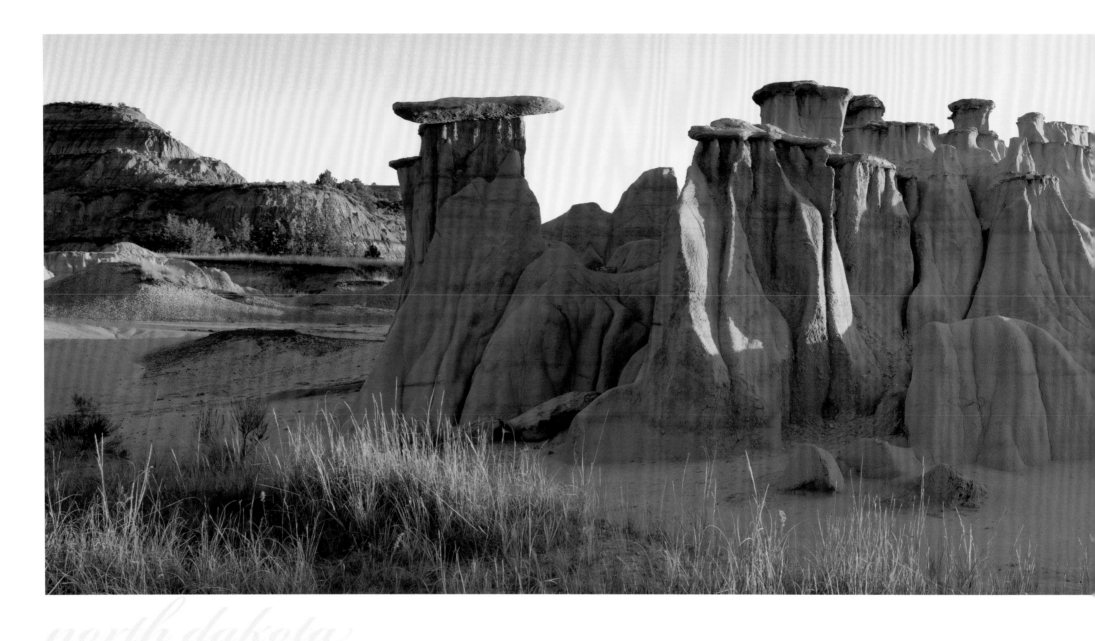

The beauty and charm of the wilderness are his for the asking, for the edges
of the wilderness lie close beside the beaten roads of the present travel.

- Theodore Roosevelt, 1916

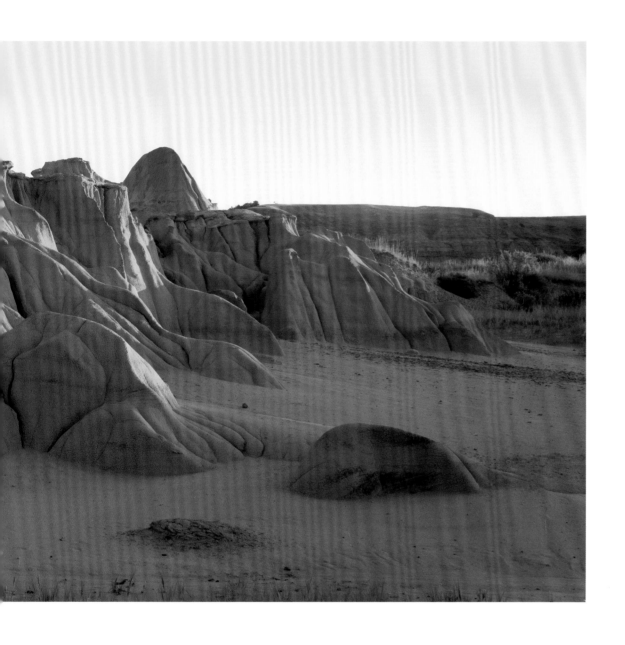

THEODORE ROOSEVELT

The colorful North Dakota badlands provide the scenic backdrop to the park, which memorializes the 26th president for his enduring contributions to conservation. In the park, you will find badlands, prairie and abundant wildlife.

Chronology of Designations

1947 · Theodore Roosevelt National
Memorial Park

1978 · Theodore Roosevelt National Park

1978 · Wilderness Area (42%)

70,447 acres

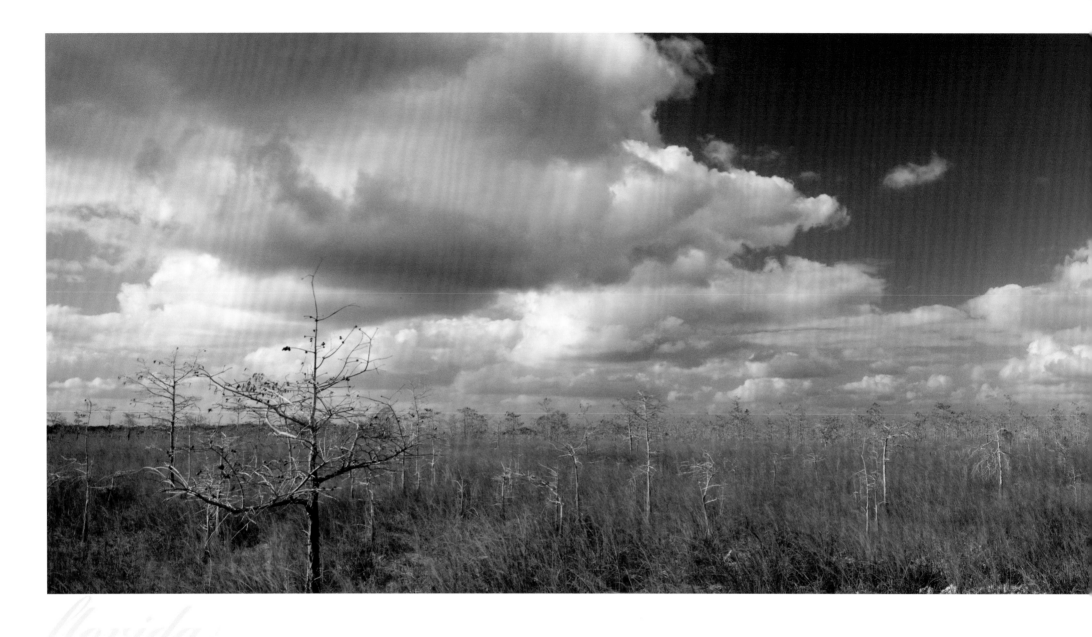

florida

There are no other Everglades in the world. They are, they have always been, one of the unique regions of the earth; remote, never wholly known. Nothing anywhere else is like them.

- Marjory Stoneman Douglas, Defender of the Everglades

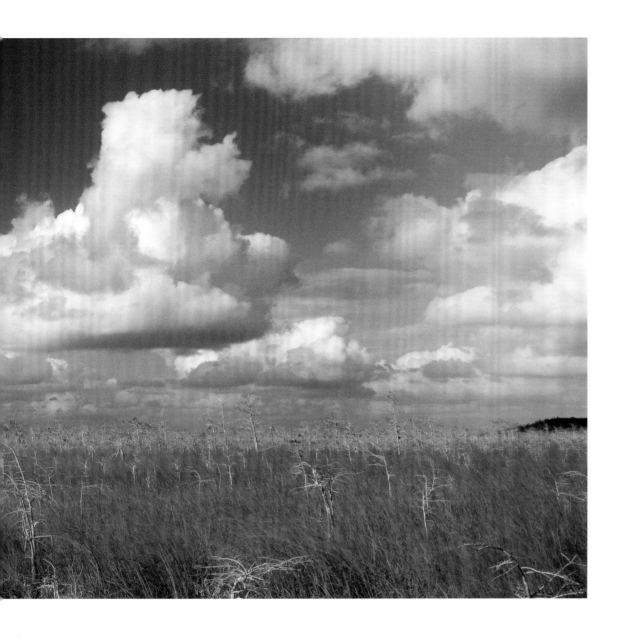

EVERGLADES

This largest remaining subtropical wilderness in the continental United States has extensive freshwater and saltwater areas, open sawgrass prairies and mangrove forests. Animals include crocodiles, alligators and abundant birdlife.

Chronology of Designations

1947 · **Everglades National Park**
1976 · Biosphere Reserve
1978 · Wilderness Area (85%)
1979 · World Heritage Site

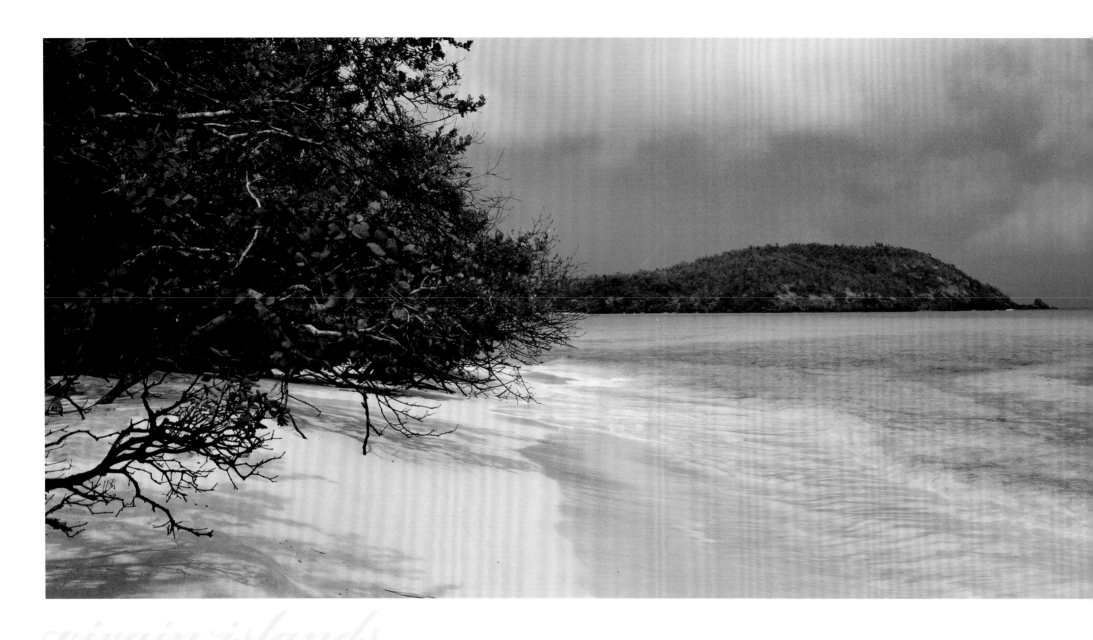

virgin islands

There was no water in the forest... God knew that the ant had it and asked her for some... The ant led God to a tree... but the tree wouldn't fall. A liana kept it from touching the ground. The macaw cut the liana with his hard, sharp beak. When the water tree fell, the sea was born from its trunk and the rivers from its branches.

- The Taino People

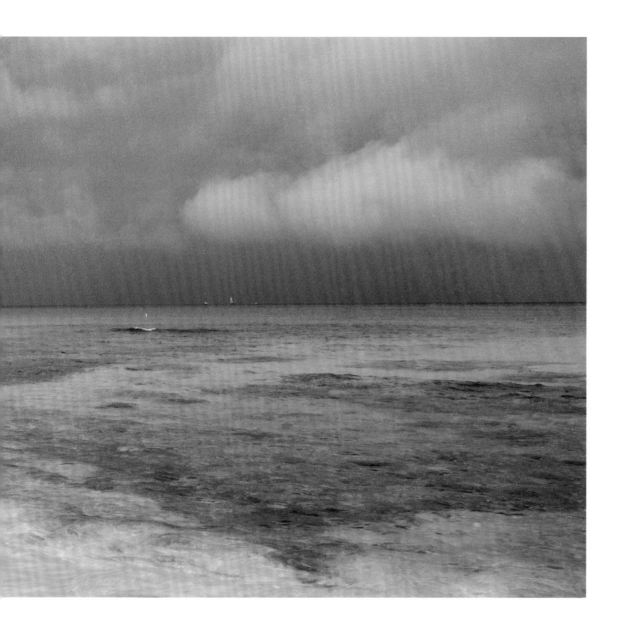

VIRGIN ISLANDS

The park includes much of the island of St. John. Features include coral reefs, quiet coves, blue-green waters and white sandy beaches fringed by verdant green hills. Here, too, are early Indian sites and remains of Danish colonial sugar plantations.

Chronology of Designations
1956 · Virgin Islands National Park
1976 · Biosphere Reserve

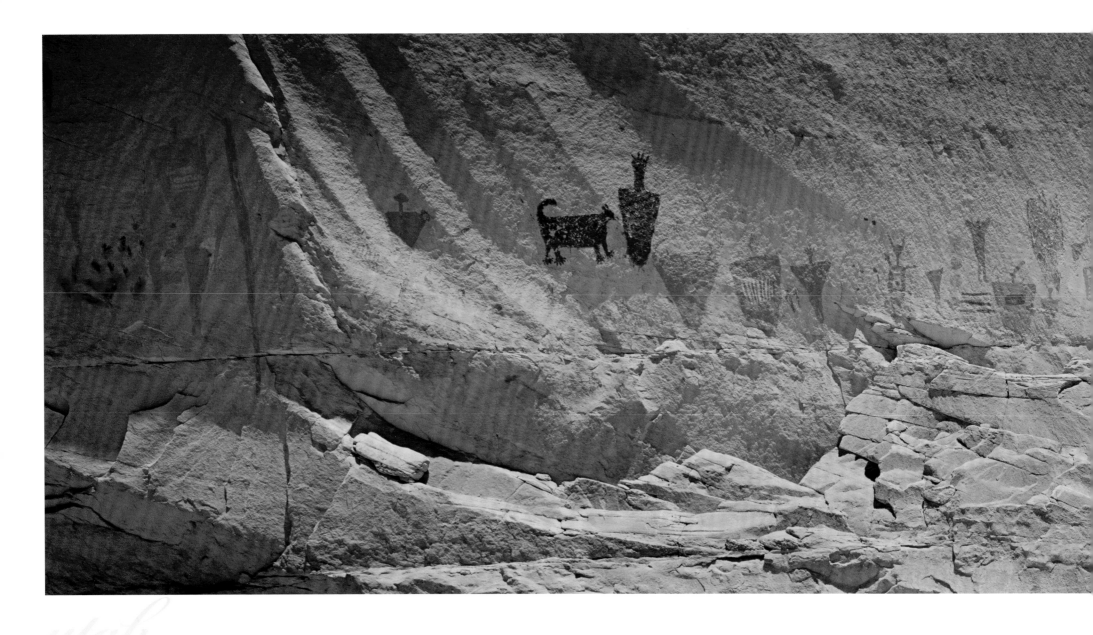

As far as the eye can see, the canyonlands country of southeastern Utah presents an array of visual wonders.
Over millions of years, the mighty lashes of wind and water gouged canyons, stripped rock layers until they bled
in a fury of color, eroded land into startling pinnacles and arches, and sliced away at the plateaued surface.

- Secretary of the Interior Stewart L. Udall, 1964

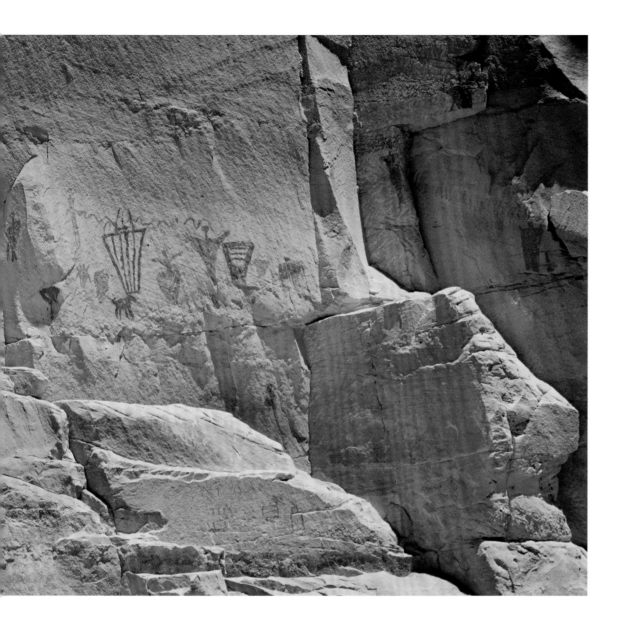

CANYONLANDS

In this geological wonderland, rocks, spires and mesas dominate the heart of the Colorado Plateau, cut by canyons of the Green and Colorado Rivers. Prehistoric Indian rock art and ruins dot the redrock landscape.

Chronology of Designations
1964 · Canyonlands National Park
1977 · Wilderness Area recommended (68%)

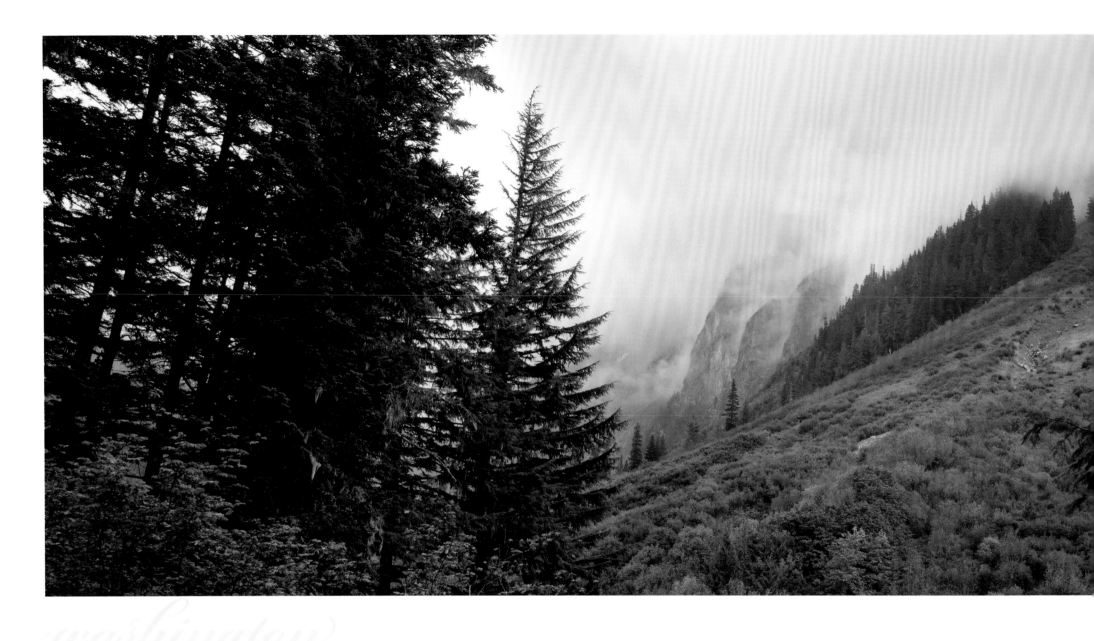

washington

I leave it to a better pen to describe the sublimity of true mountain scenery in the Cascade Mountains...
it must be seen, it cannot be described... Whoever wishes to see nature in all its primitive glory and
grandeur, in its almost ferocious wildness, must go and visit these mountain regions.

- Henry Custer, 1859

NORTH CASCADES

In this wilderness park, high, jagged peaks intercept moisture-laden winds, producing glaciers, waterfalls, rivers, lakes, lush forests and a great diversity of plants and animals.

Chronology of Designations
1968 · North Cascades National Park
1988 · Wilderness Area (99%)

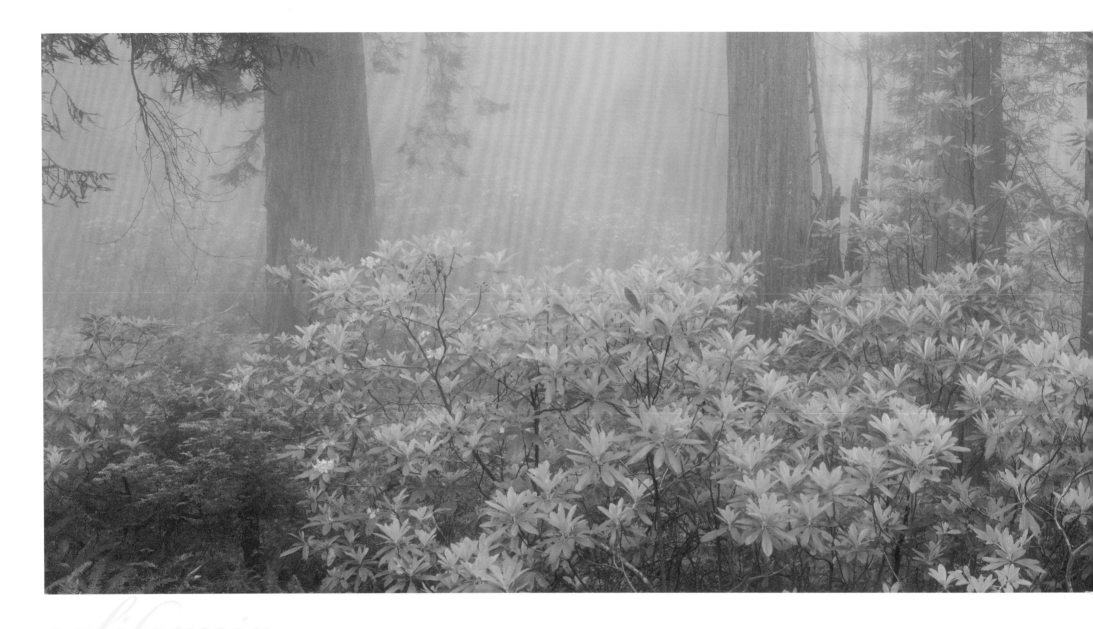

california

Our people have always lived on this sacred and wondrous land along the Pacific Coast and inland on the Klamath River, since the Spirit People, Wo-ge' made things ready for us and the Creator, Ko-won-no-ekc-on Ne-ka-nup-ceo, placed us here. From the beginning, we have followed all the laws of the Creator, which became the whole fabric of our tribal sovereignty. In times past and now, Yurok people bless the deep river, the tall redwood trees, the rocks, the mounds and the trails.

- Constitution of the Yurok People

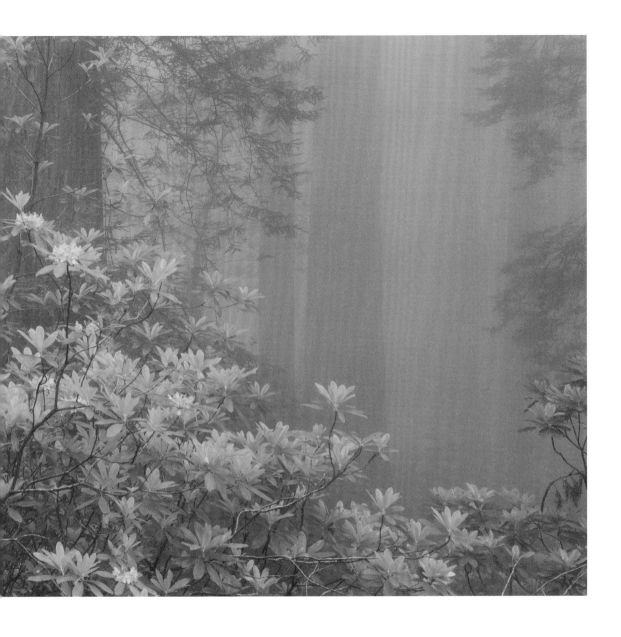

REDWOOD

Coastal redwood forests with virgin groves of ancient trees—including the world's tallest—thrive in the foggy, temperate climate of the northern California coast. The park includes 37 miles of scenic Pacific shoreline.

Chronology of Designations
1968 · Redwood National Park
1980 · World Heritage Site
1983 · Biosphere Reserve
1994 · Redwood National and State Parks

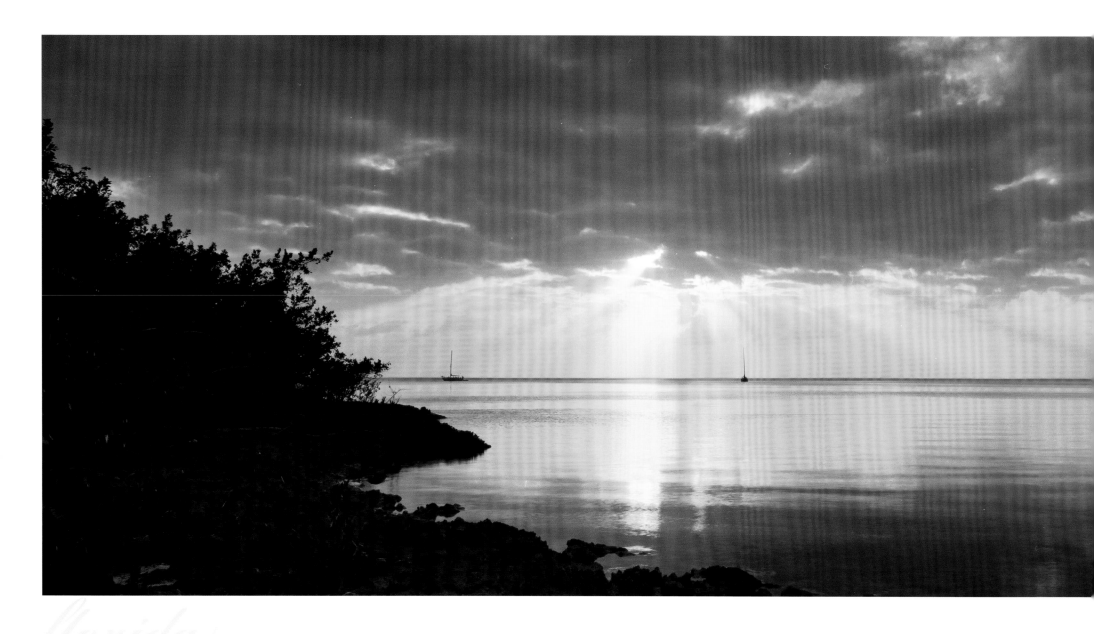

No sea-lover could look unmoved on the blue rollers of the Gulf Stream and the crystal-clear waters of the reef, of every delicate shade of blue and green, and tinged with every color of the spectrum from the fantastically rich growths on the bottom, visible to the last detail through this incredibly translucent medium. It scarcely resembles northern sea water at all—a cold, semi-opaque, grayish-green fluid, which hides the mysteries of the bottom. Drifting over the Florida Reef on a quiet day one may note all the details of its tropical luxuriance twenty feet below, and feels himself afloat on a sort of liquid light, rather than water, so limpid and brilliant is it.

- Commodore Ralph Middleton Munroe, 1877

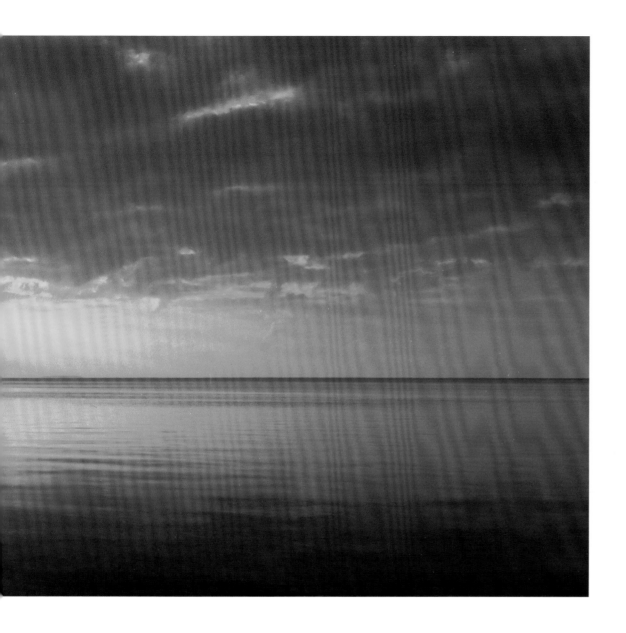

BISCAYNE

This large marine park protects and preserves interrelated marine ecosystems, including mangrove shoreline, bay community, subtropical islands and the northernmost coral reef in the United States. Ninety-five percent of the park is under water.

Chronology of Designations
1968 · Biscayne National Monument
1980 · Biscayne National Park

172,924 acres

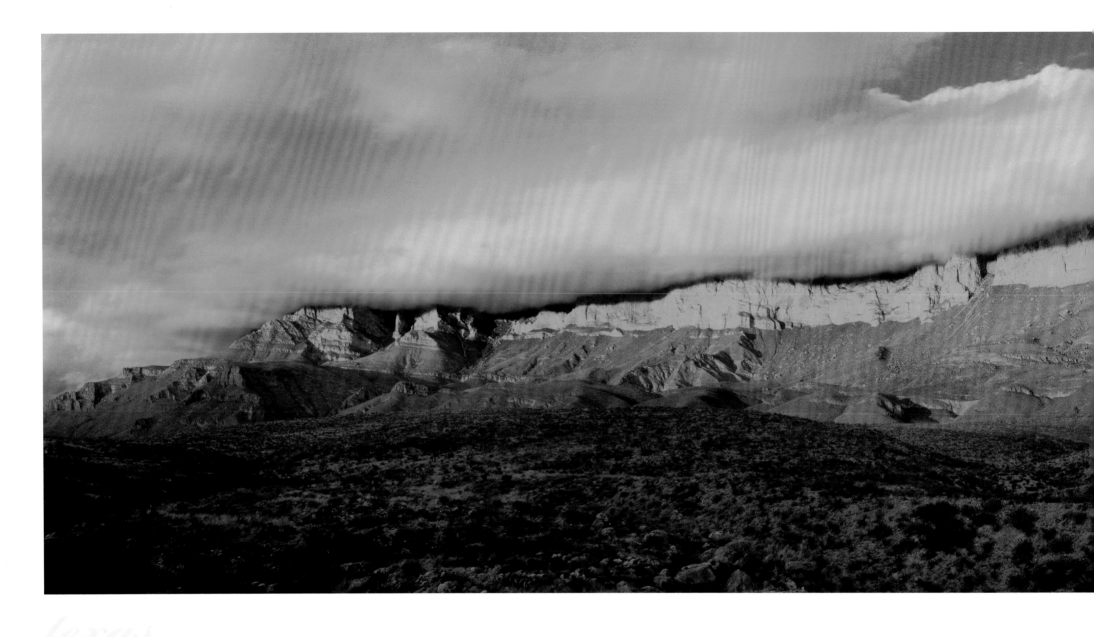

The Guadalupes help you to understand the desert in a deeper way: they demonstrate the Earth's ability
to produce and sustain life and to create delicate interludes even in the most difficult circumstances.

- Lawrence W. Cheek, 2001

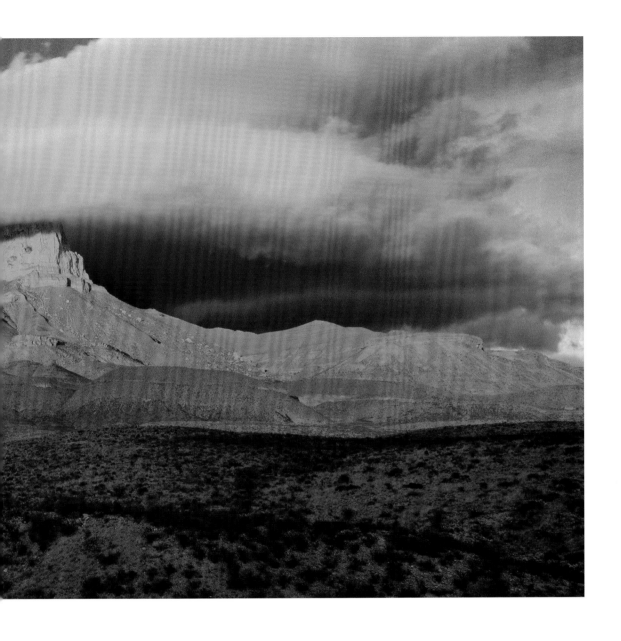

GUADALUPE MOUNTAINS

This lofty mountain mass rising out of the Chihuahuan Desert is part of the world's most ancient Permian limestone fossil reef. The park includes spectacular canyons and unusual plants and animals. Guadalupe Peak, the highest point in Texas at 8,749 feet, is found here.

Chronology of Designations
1972 · Guadalupe Mountains National Park
1978 · Wilderness Area (54%)

86,416 acres

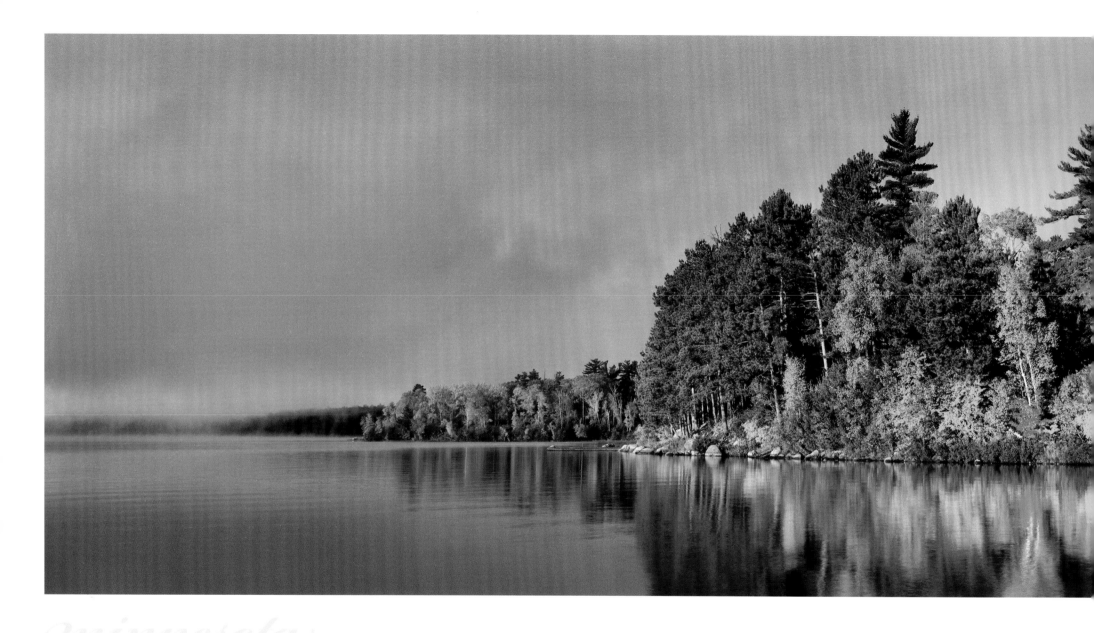

minnesota

I will always remember this place and long for it a little. Islands of gold and green, the wind in great branches, an owl's call in the rainy dusk, the scent of our wood smoke drifting across the moonlight.

- Florence Page Jaques, 1938

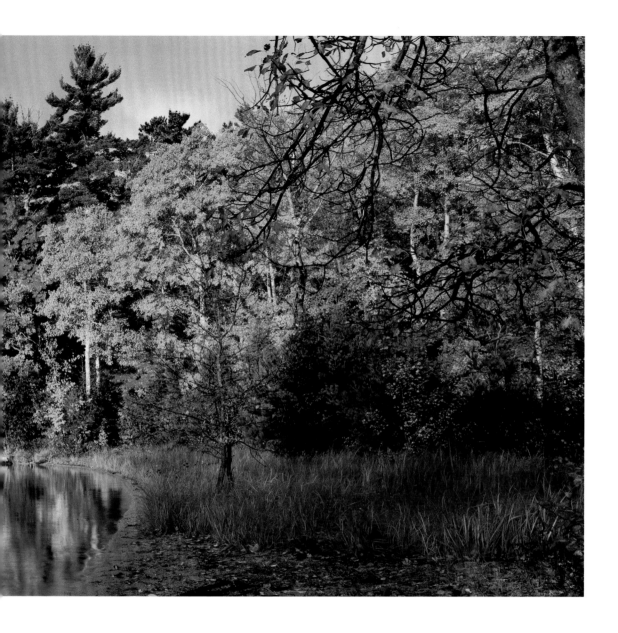

VOYAGEURS

The waterway of four large lakes connected by narrows was once the route of the French-Canadian voyageurs. With more than 500 islands, the lakes surround a peninsula of boreal forest.

Chronology of Designations
1975 · Voyageurs National Park
1992 · Wilderness Area proposed (58%)

218,200 acres

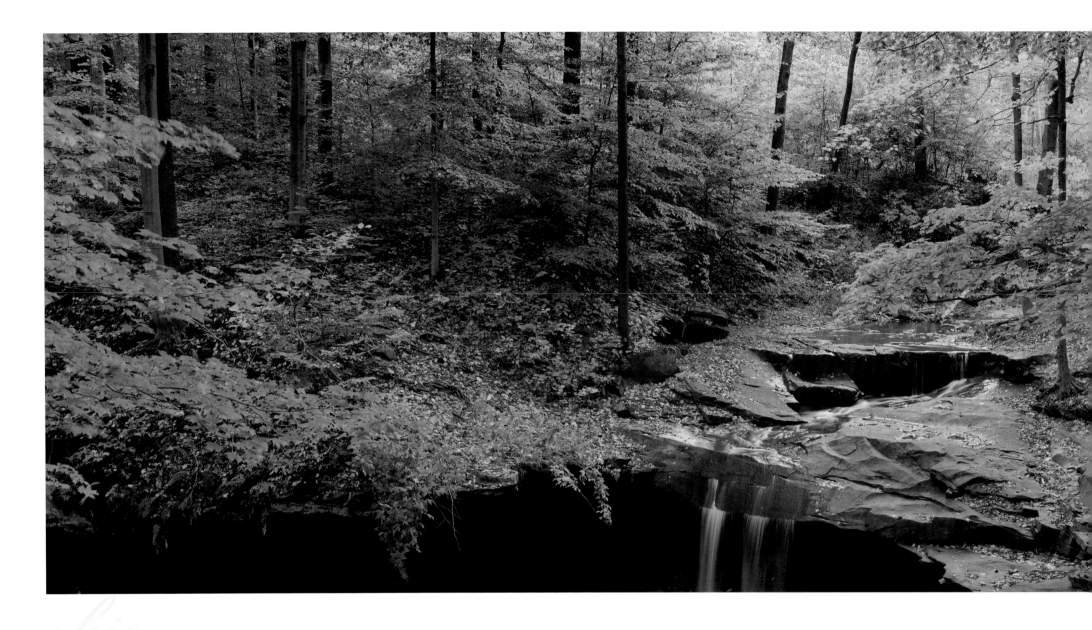

There is a wealth of beautiful scenery in your county—the wonderful and impressive landscape of the Cuyahoga Valley north of Akron, the many and varied wooded ravines running up from this main valley to the plateau land on either side, and large stretches of gently rolling pastoral landscape, streams and lakes, occasional gorges and picturesque ravines where the streams have worn through the sandstone strata, and some hills of a more or less rugged character commanding broad outlooks over the countryside.

- Olmsted Brothers Report on a Park System for Summit County, Ohio, 1925

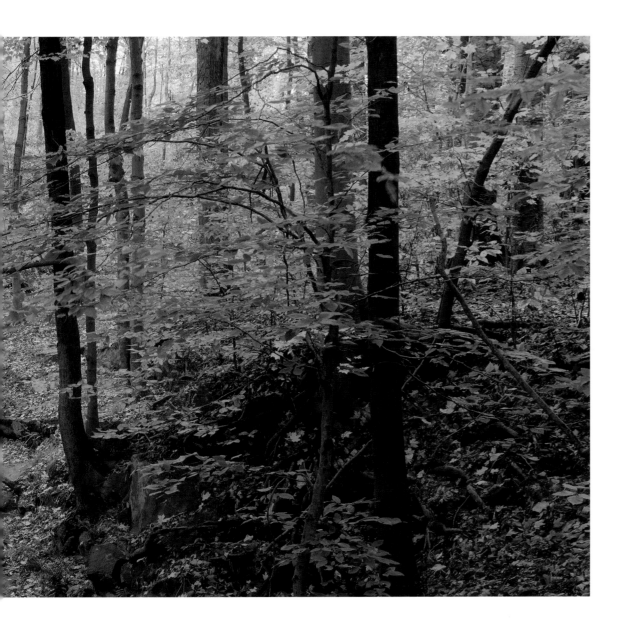

CUYAHOGA VALLEY

This area preserves rural landscapes along the Cuyahoga River between Cleveland and Akron, Ohio. The 20-mile Ohio & Erie Canal Towpath Trail within the park follows the historic route of the canal. Historic structures and natural features can be seen as it continues along the Ohio & Erie National Heritage Canalway, showcasing this area's rich transportation history.

Chronology of Designations
1975 · Cuyahoga Valley National Recreation Area
2000 · Cuyahoga Valley National Park

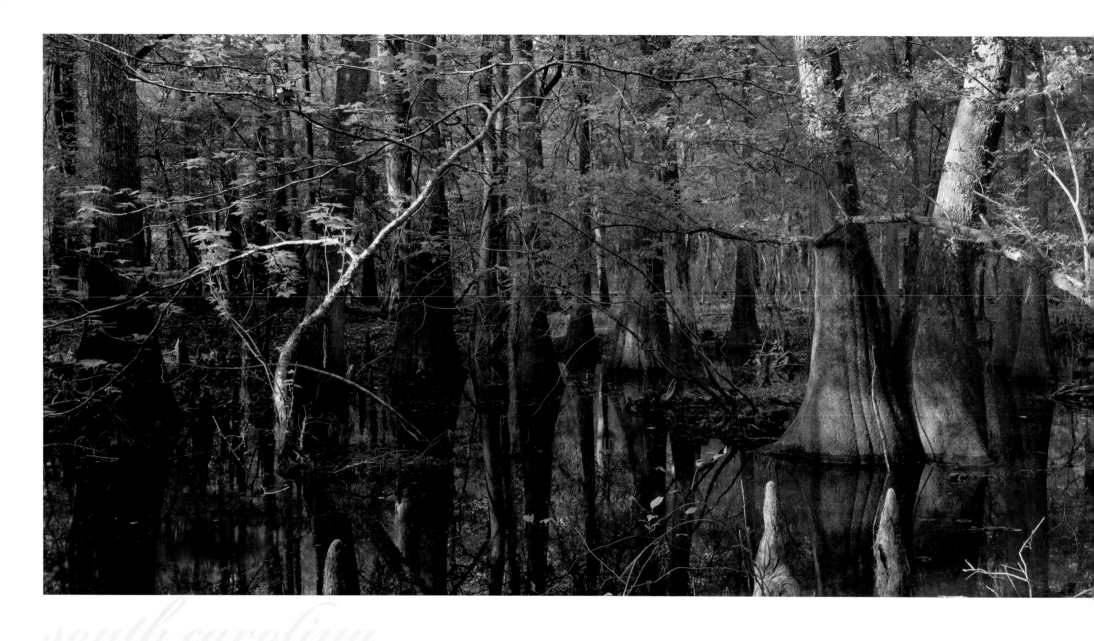

From the ground it is a silent cathedral, the streaming rays of the afternoon
sun not yet blocked out by the burgeoning spring foliage, silent and majestic.

- Mike Bowen, 1974

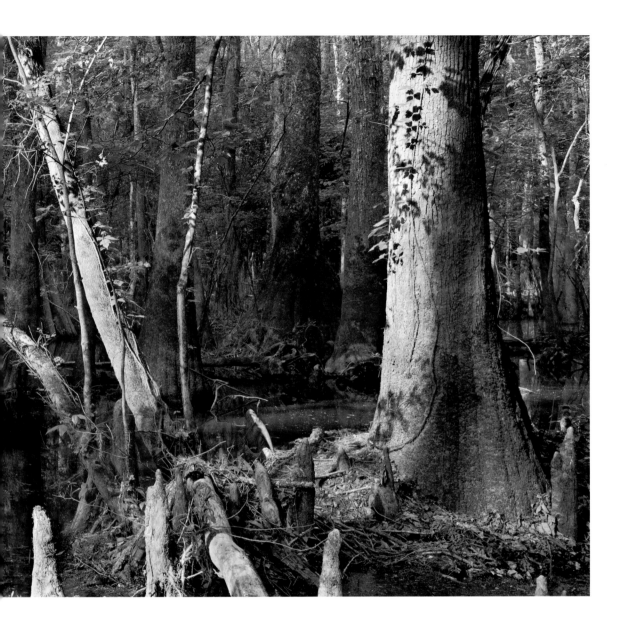

CONGAREE

The park protects the last significant tract of southern bottomland hardwood forest in the United States. It is home to a rich diversity of plant and animal species associated with an alluvial floodplain. Several national and state record trees are located in the park.

Chronology of Designations
1976 · Congaree Swamp National Monument
1983 · Biosphere Reserve
1988 · Wilderness Area (68%)
2003· Congaree National Park

26,546 acres

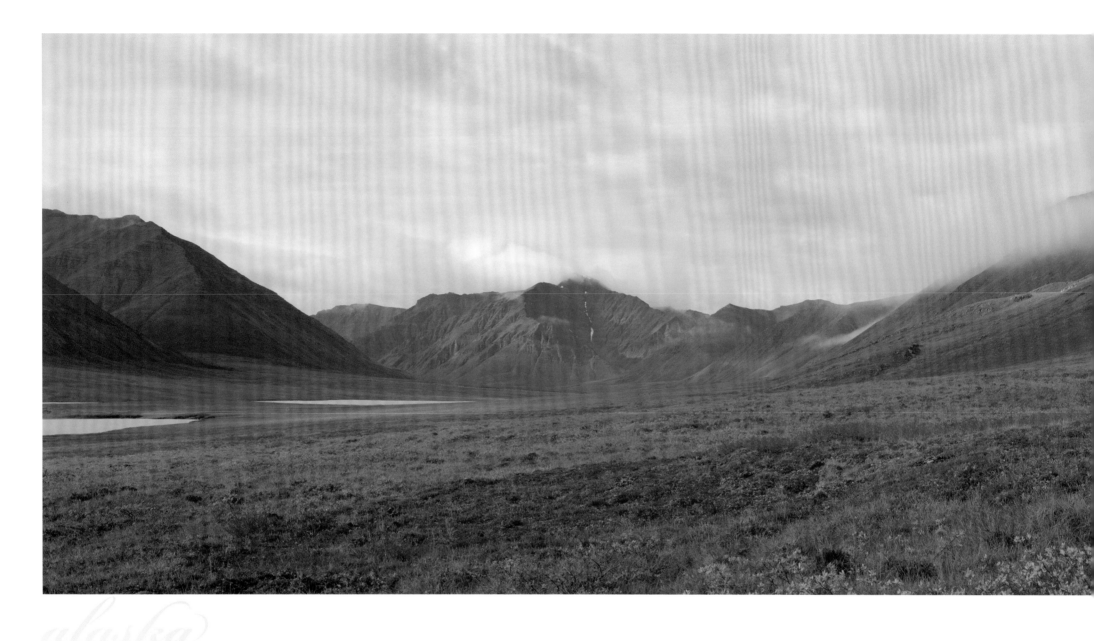

Remote canyons, rugged peaks, wild rivers, pristine lakes and vast herds of caribou seem all but lost in its expanse. Vast and austere, stern, stark and uncompromising, yet possessed of haunting beauty. It offers that total immersion in wilderness that has ever been an essential part of life in the New World.

- William E. Brown and Carolyn Elder, 1982

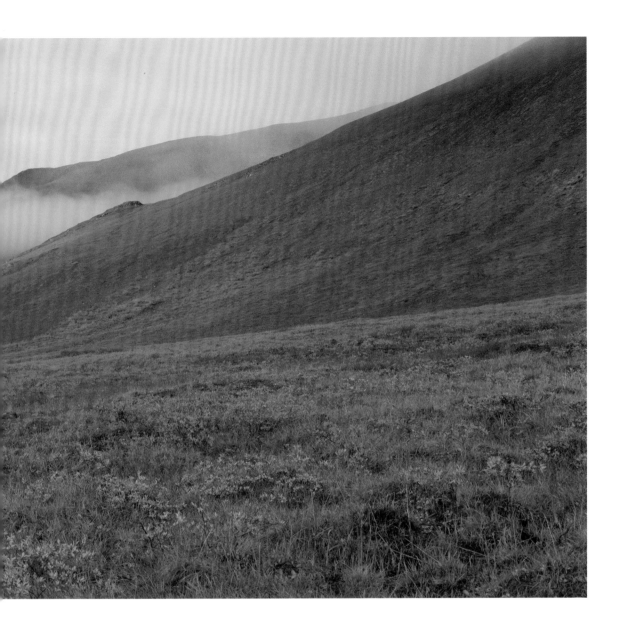

GATES OF THE ARCTIC

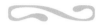

Lying entirely north of the Arctic Circle, this huge park and preserve includes much of the Central Brooks Range, the northernmost extension of the Rocky Mountains. This landscape is characterized by jagged peaks, broad Arctic valleys, wild rivers, remnant glaciers and numerous lakes. Combined with the adjacent Noatak Wilderness, this area forms the largest designated wilderness area in the world.

Chronology of Designations
1978 · Gates of the Arctic National Monument
1980 · Gates of the Arctic National Park and Preserve
1980 · Wilderness Area (85%)

8,472,517 acres

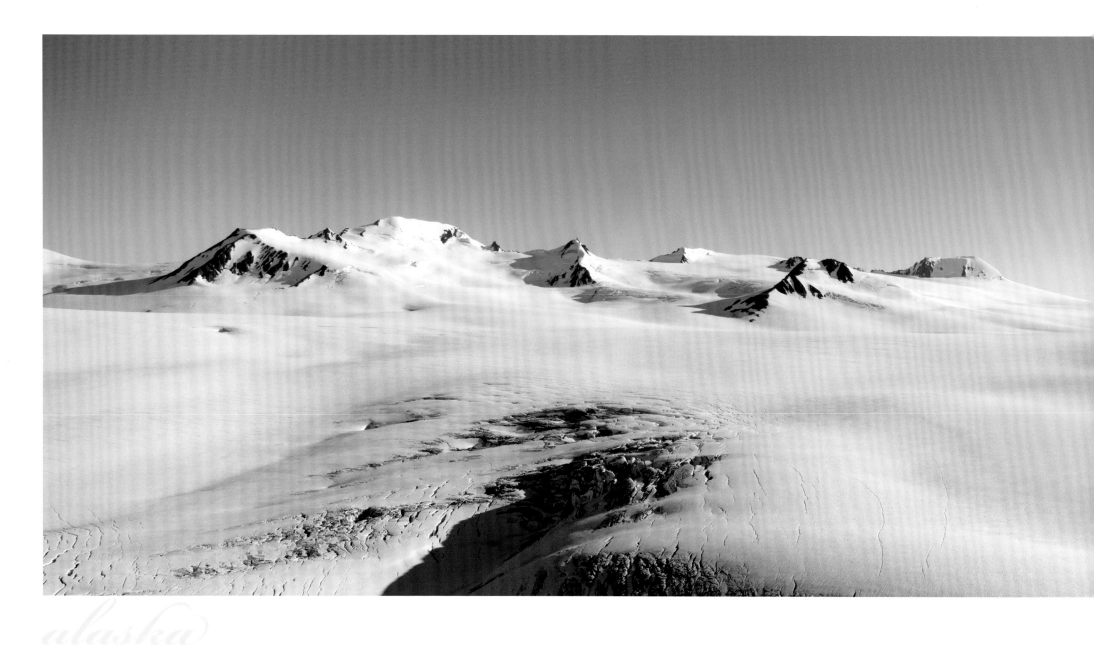

alaska

I got a church. It's the whole outdoors. And the goodness in people.
You'd be surprised how many nice people there are.

- Otto Thiele Sr., 2002

KENAI FJORDS

The park includes one of the four major icecaps in the United States—300-square-mile Harding Icefield—and coastal fjords. Here a rich, varied rainforest is home to tens of thousands of breeding birds, and adjoining marine waters support a multitude of sea lions, sea otters and seals.

Chronology of Designations
1978 · Kenai Fjords National Monument
1980 · Kenai Fjords National Park

669,541 acres

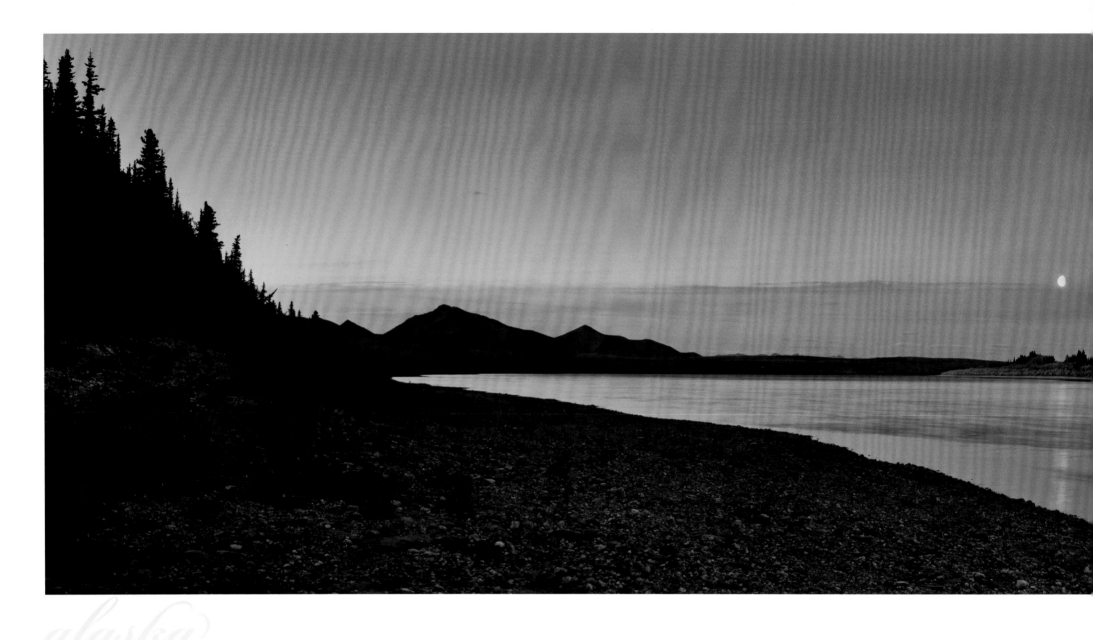

In December, the sun disappears below the horizon and "darkness" officially descends upon the arctic. This notion of a lack of light creates a mistakenly grim picture of a truly glorious winter. Here, during the clearer, colder days, the arctic's particular beauty becomes especially distinct at twilight (in the afternoon!), as stars present themselves in an almost neon-blue sky rimmed with a salmon-pink horizon.

- Susan B. Andrews and John Creed, 1998

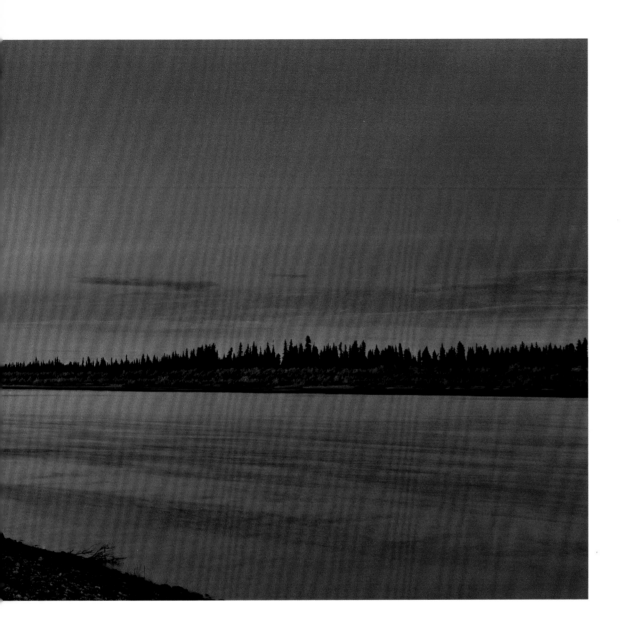

KOBUK VALLEY

Embracing the central valley of the Kobuk River, the park, located north of the Arctic Circle, includes a blend of biological, geological and archeological resources. Here, in the northernmost extent of the boreal forest, a rich array of Arctic wildlife can be found, including caribou, grizzly and black bear, wolf and fox.

Chronology of Designations
1978 · Kobuk Valley National Monument
1980 · Kobuk Valley National Park
1980 · Wilderness Area (10%)

1,750,421 acres

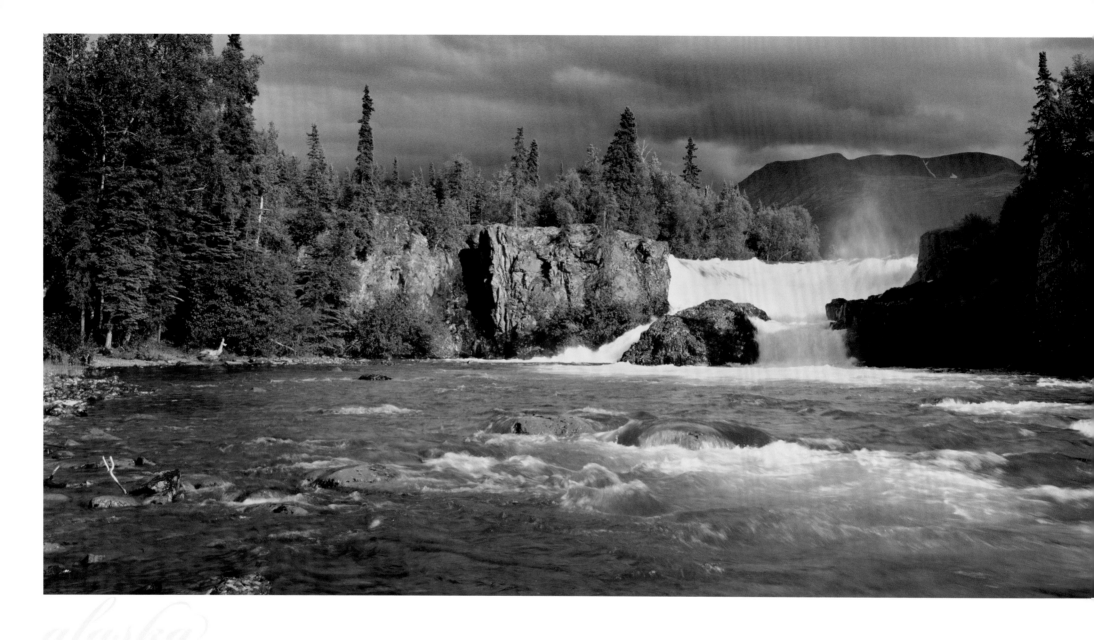

Somehow I never seem to tire of just standing and looking down the lake or up at the mountains in the evening even if it is cold. If this is the way folks feel inside a church, I can understand why they go.

- Richard Proenneke

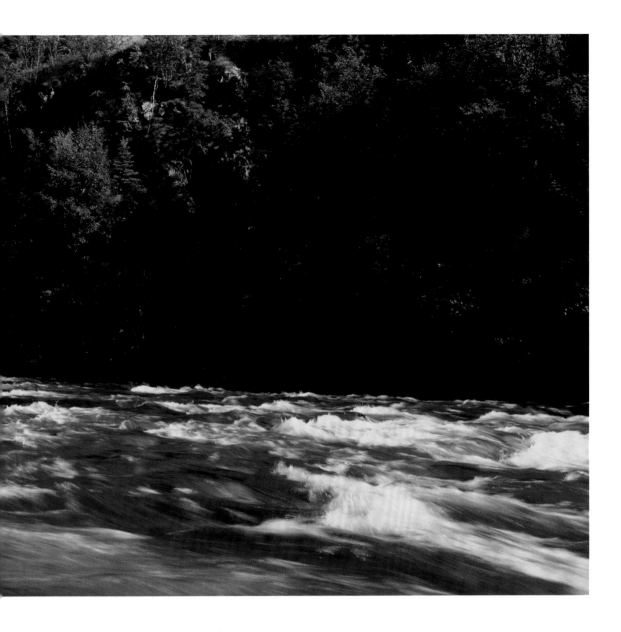

LAKE CLARK

Located in the heart of the Chigmit Mountains, the park and preserve contains great geologic diversity, including jagged peaks, granite spires and two symmetrical active volcanoes. More than a score of glacially carved lakes rim the mountain mass. Lake Clark, at more than 40 miles long, is the largest lake in the park and preserve, and the sixth largest lake in Alaska. It is also the headwaters for red salmon spawning and the northern reaches of the Bristol Bay watershed.

Chronology of Designations
1978 · Lake Clark National Monument
1980 · Lake Clark National Park and Preserve
1980 · Wilderness Area (65%)

4,045,300 acres

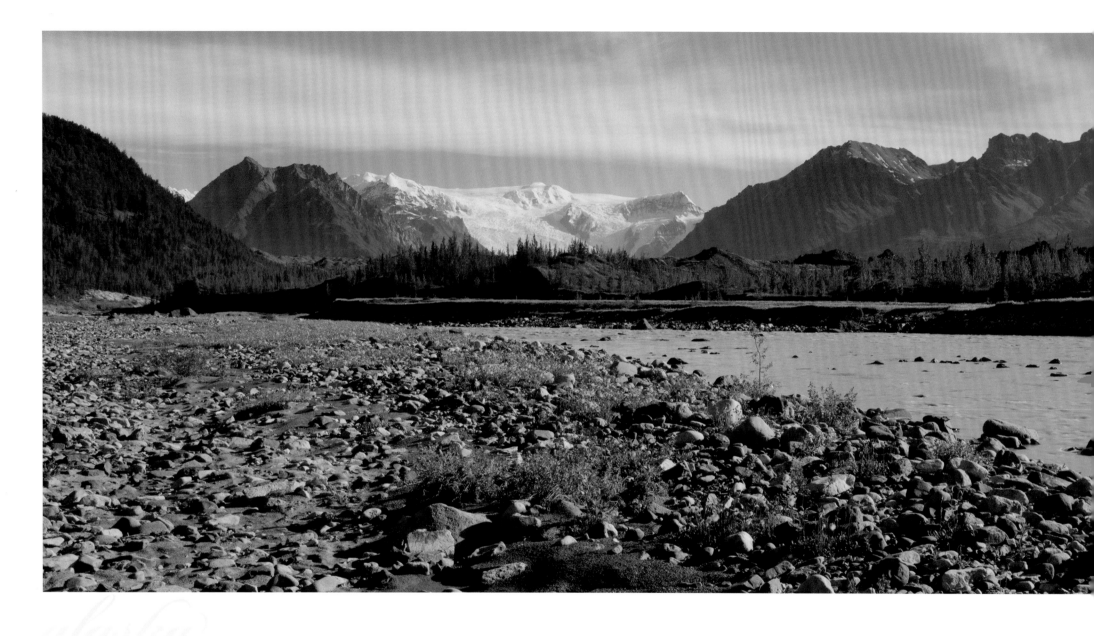

Long before recorded history, the human experience was conceived in and born of wilderness. In the deepest recesses of our hearts resonates a longing to reach out and once again grasp those primal areas. It is reassuring to know that the experience is available in those places of truly majestic wilderness—places like Wrangell-St. Elias.

- George Mobley

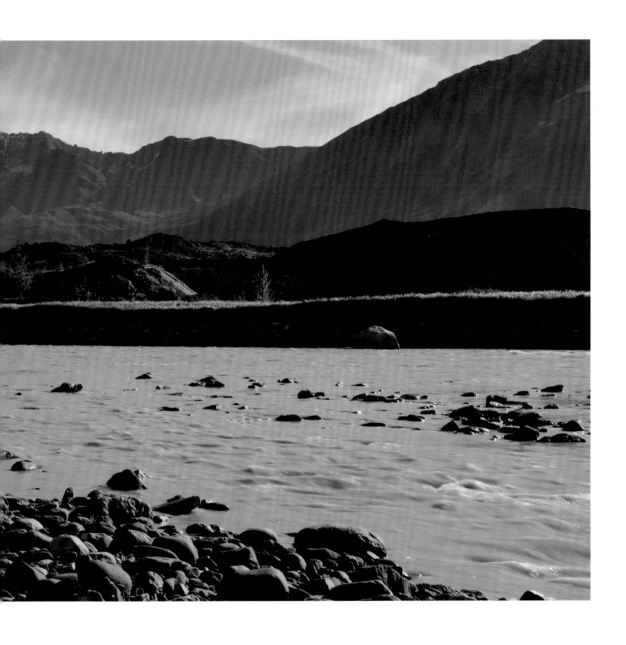

WRANGELL-ST. ELIAS

The Chugach, Wrangell and St. Elias mountain ranges converge here in what is often referred to as the "mountain kingdom of North America." The largest land-based unit of the National Park System, less than a day's drive east of Anchorage, this spectacular park includes the continent's largest assemblage of glaciers and greatest collection of peaks above 16,000 feet. Mount St. Elias, at 18,008 feet, is the second highest peak in the United States.

Chronology of Designations
1978 · Wrangell-St. Elias National Monument
1979 · World Heritage Site
1980 · **Wrangell St. Elias National Park and Preserve**
1980 · Wilderness Area (69%)

13,188,024 acres

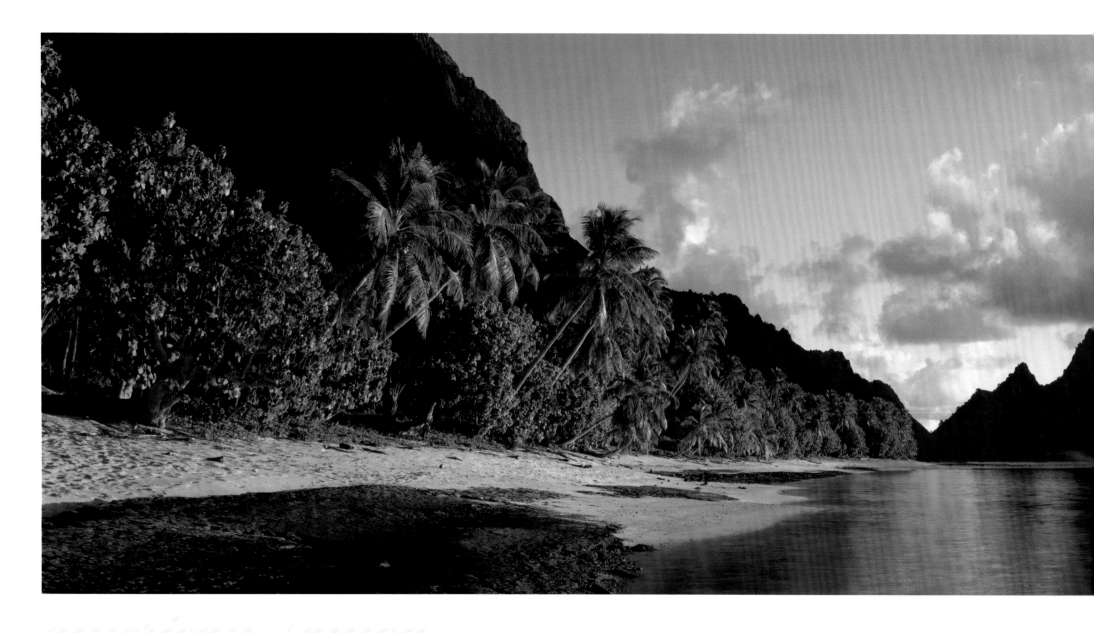

Here are high rain forests poking up through clouds, surf-beaten cliffs and quiet coves where seabirds nest, lush vegetation from coastline to mountaintop, pristine water curling to foam atop a fringing reef that is home to brilliant coral and extravagant marine life. Here, too, are the artifacts and sacred precincts of an ancient culture and the villages where that culture—fa'a Samoa, the Samoan way—persists today.

- The Sierra Club Guides to the National Parks
of California, Hawai'i and American Samoa, 1996

AMERICAN SAMOA

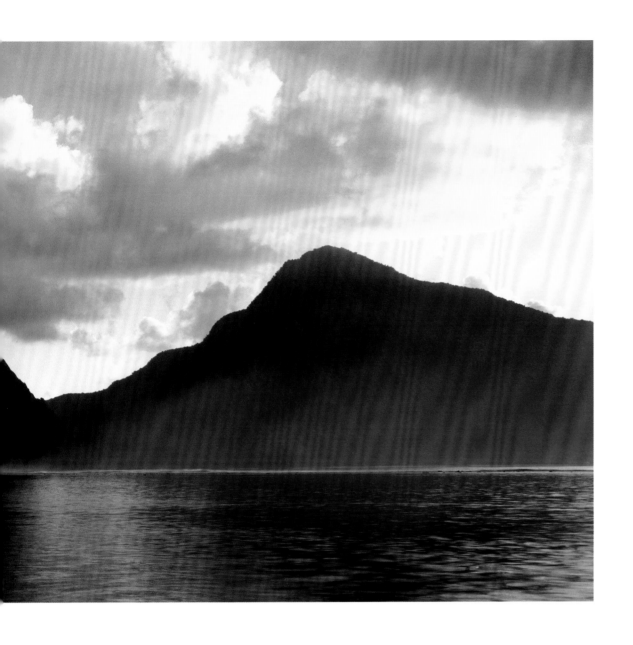

Some 2,600 miles southwest of the Hawaiian Islands, this is the most remote national park and the only one south of the equator. Set aside to preserve Old World rainforests and South Pacific coral reefs, the park contains leased land on three rugged, tropical volcanic islands draped in a cloak of green. Fittingly, "Samoa" means "sacred Earth." The park also protects fa'asamoa, the customs, beliefs and traditions of the 3,000-year-old Samoan culture.

Chronology of Designations
1993 · National Park of American Samoa

10,500 acres

The Significance of the National Parks

by Ruth Rudner

Our national parks are places of exploration. Whether venturing deep into the backcountry or gazing at magnificent features from paved walkways, one engages in the exploration of unknown paths, of new sights and sounds, and of one's own mind in the face of wild places. National parks are America's memory, the heart of its history and the preservation of its future. They protect the irreplaceable landscapes of our primordial legacy, the remnants of the continent's aboriginal vastness, the environment that shaped the American soul. National parks offer the opportunity to engage with all that inspired a nation's thrust toward exploration, adventure and challenge.

The brilliance of the national park idea is the vision to preserve examples of the earth's magnificence for all to enjoy. Today, where much wild country is unprotected, even remote lands are etched by roads, scarred by development and depleted through resource extraction. National parks remind us of the once-sacred wholeness of the earth. It is here that we see how nature's parts interact with the whole as a functioning ecosystem. National park visitors encounter an America of dreams, a land where the chain of life is left alone to unfold as nature intended, a land where the mythic vision of a new world continues to exist. Since the establishment of Yellowstone as the first national park in 1872, the federal government has designated a total of 58 national parks to celebrate America's natural values. One hundred and eighty-eight other countries have embraced this uniquely American invention, designating more than 4,000 national parks and equivalent reserves worldwide. Inspired as the national park idea was, it still took time to get things right. It wasn't until the Organic Act of 1916 created the National Park Service that the concepts of protecting natural resources and providing for the visitor experience really took hold. The Organic Act states that the purpose of the national parks is to …*conserve the scenery and the natural and historic objects and the wild life therein, and to provide for the enjoyment of the same in such manner and by such means as will leave them unimpaired for future generations.*

The phrase requiring the National Park Service to provide "enjoyment" has often been read as a mandate to build ever more visitor services—frequently at the expense of wild land and animals—although the governing value has always placed conservation over recreation. For a time, this was interpreted as saving the "good animals"—the vegetarians—while ridding the parks of predators. More recently, scientists and park management recognized that prey and predators form a unit and that one cannot exist without the other. Prey species will decimate a landscape without their predators and will soon fall victim to the ravages of overpopulation. Without predators, prey species also lose their wariness, which is, perhaps, the soul of the wild. By bringing important aspects of nature together—predator, prey and the habitats that support them—national parks engage in an expression of wildness, of health, of an ecology that invites visitors to enter into their own connection with all of life.

National parks are natural universities offering learning opportunities in geology, geography, hydrology, botany, biology, meteorology and, perhaps most importantly, the unclassified science of wonder. Whether by personal observation or with the help of a guide or guidebook, visitors have endless opportunities to experience nature's connections first-hand—to see how the flora and fauna interact with the elements and to witness the persistence of life on our planet.

National parks are fishbowls where little happens that goes unnoticed. When pollution beyond national park borders impacts a park's delicate ecological balance, it gets noticed. Whether from chemicals, noise, light or any other pollutant, the negative impact creates public outcry and debate. Even when park officials are helpless to control events beyond their borders, such situations demand public attention because they impact *our* national parks—a birthright granted to all Americans. With ownership comes responsibility and the need for all Americans who care to reinforce the national park ideal. In this way, national parks become a vital stimulus for increasing environmental sensitivity and for community outreach.

Whether driving through in a day or spending a week in the backcountry, national park visitors are offered the wonders and exhilaration of nature. For some, it is a new experience. For others, it is going home. Whatever is celebrated in the park's landscape—desert, forest, mountain, river or lake, prairie or cavern—our national parks provide visitors the opportunity to engage with the earth. Engaging with the earth is the essence of existence.

All of this is the significance of our national parks.

A former Yellowstone horsepacking guide, author of twelve books and numerous articles, Ruth Rudner writes about the natural world. Her newest books are Our National Parks, *in collaboration with her husband, photographer David Muench, and* Ask Now the Beasts (Our Kinship With Animals Wild and Domestic). *Recent books include* A Chorus of Buffalo (A Personal Portrait of an American Icon), *and* Windstone, *also a collaboration with David Muench.*

This Book Was Made Possible by the Collaborative Efforts of the Following Partners:

NATIONAL PARK SERVICE, YOSEMITE NATIONAL PARK · The National Park Service preserves unimpaired the natural and cultural resources and values of the National Park System for the enjoyment, education, and inspiration of this and future generations. The National Park Service cooperates with partners to extend the benefits of natural and cultural resource preservation and outdoor recreation throughout the United States.

www.nps.gov

EASTERN NATIONAL · Eastern National—a not-for-profit partner of the National Park Service for over 60 years—provides quality products and services to visitors of America's national parks and other public trusts. Headquartered outside of Philadelphia, PA, the organization has donated over $89 million to the National Park Service to support interpretive and educational programs. Eastern National operates museum shops in parks throughout the United States, helping visitors better understand the parks and their resources. Each year, Eastern National donates its profits to the National Park Service to support park programs. Your purchases in park visitor centers support park education programs! Shop online at www.eParks.com

www.easternnational.org

EMPLOYEES & ALUMNI ASSOCIATION OF THE NATIONAL PARK SERVICE · The heart of the National Park Service is its employees; the dedicated, 20,000-plus strong workforce that maintains, interprets, protects and manages our national parks. The Employees & Alumni Association of the National Park Service (E&AA) is a membership organization dedicated to promoting the values and ideals of the National Park Service. The E&AA membership is a diverse group of current employees, alumni, volunteers and other interested partners who see the National Park Service, and its family, as important parts of their lives. E&AA members are dedicated to the mission and work of the National Park Service.

www.eandaa.org

NATURE VALLEY · Nature Valley gives you the energy to actively enjoy the outdoors. Because we provide a wholesome source of energy, we are proud to help support these important lands and promote responsible ways to experience the beauty of America's national parks. We hope that you treasure these photos as much as we do and that you'll be inspired to visit all of these majestic places in person, as well as in this book.

www.naturevalley.com

AMERICAN PARK NETWORK · *American Park Network* publishes the world's largest outdoor guides, read by over 20 million national park enthusiasts each year. Its mission to support national parks and public lands has been a driving force for more than two decades. The publication of *America's Best Idea* is just one example of the meaningful results that can be achieved through creative public/ private partnerships. This book would not have been possible without the collaborative efforts of all the partners listed here. Hopefully this project will serve as inspiration for new partnerships that will help preserve our natural and cultural resources, unimpaired for the enjoyment of future generations.

www.americanparknetwork.com

Citations

HOT SPRINGS NATIONAL PARK

McLane, Bobbie Jones, Charles William Cunning, and Wendy Bradley Richter, eds. Observations of Arkansas: The 1824-1863 Letters of Hiram Abiff Whittington. Hot Springs, AR: Garland County Historical Society, 1997.

YOSEMITE NATIONAL PARK

Rusk, Ralph L., ed. "Four Letters to Emerson." The Letters of Ralph Waldo Emerson. 6 vols. New York and London: Columbia University Press, 1939. pp. 154-157, 202-204.

YELLOWSTONE NATIONAL PARK

United States Congress. Yellowstone Act, 1872: An Act to Set Apart a Certain Tract of Land Lying Near the Headwaters of the Yellowstone River as a Public Park (Approved March 1, 1872 – 17 Stat 32).

SEQUOIA NATIONAL PARK

Muir, John. Our National Parks. Boston and New York: Houghton Mifflin and Co., 1901.

KINGS CANYON NATIONAL PARK

King, Clarence. Mountaineering in the Sierra Nevada. Boston: J.R. Osgood and Co., 1871.

GRAND CANYON NATIONAL PARK

Burnham, Philip. Indian Country, God's Country: Native Americans and the National Parks. Washington, D.C.: Island Press, 2000.

MOUNT RAINIER NATIONAL PARK

Carpenter, Cecelia Svinth. Where the Waters Begin – The Traditional Nisqually Indian History of Mount Rainier. Seattle: Northwest Interpretive Association, 1994.

CRATER LAKE NATIONAL PARK

National Geographic Book Service. National Geographic's Guide to the National Parks of the United States. Washington, D.C.: National Geographic Society, 1989.

WIND CAVE NATIONAL PARK

McDonald, Alvin F. The Private Account of A.F. McDonald, Permanent Guide of Wind Cave. Unpublished, 1893.

MESA VERDE NATIONAL PARK

Ortiz, Alfonso. The Tewa World: Space, Time, Being and Becoming in a Pueblo Society. Chicago: University of Chicago Press, 1969.

PETRIFIED FOREST NATIONAL PARK

Lummis, Charles F. Some Strange Corners of Our Country – A Forest of Agate. New York: The Century Co., 1892.

LASSEN VOLCANIC NATIONAL PARK

Strong, Douglas Hilman. These Happy Grounds: A History of the Lassen Region. Red Bluff, CA: Walker Lithograph Co., 1973. Mineral, CA: Loomis Museum Association, 1973.

OLYMPIC NATIONAL PARK

The Olympic Peninsula Intertribal Cultural Advisory Committee. Native Peoples of the Olympic Peninsula. Ed. Jacilee Wray. Norman, OK: University of Oklahoma Press, 2002.

ZION NATIONAL PARK

The Tertiary History of the Grand Canyon District. U.S. Geological Survey Monographs, 1882.

GLACIER NATIONAL PARK

Tilden, Freeman. The National Parks. New York: Alfred A. Knopf, 1951.

ROCKY MOUNTAIN NATIONAL PARK

Mills, Enos A. The Rocky Mountain National Park. Garden City, NY: Doubleday, Page, and Co., 1924.

ACADIA NATIONAL PARK

Dorr, George B. Acadia National Park: Its Origin and Background. Bangor, ME: Burr Printing Co., 1942.

HAWAI'I VOLCANOES NATIONAL PARK

Pele Hanoa, a Hawaiian elder on her birthday, 2004.

HALEAKALĀ NATIONAL PARK

Whitney, Henry M. The Hawaiian Guide Book, for Travelers: Containing a Brief Description of the Hawaiian Islands, their Harbors, Agricultural Resources, Plantations, Scenery, Volcanoes, Climate, Population, and Commerce. Honolulu: H.M. Whitney, 1875.

DENALI NATIONAL PARK AND PRESERVE

Nelson, Richard K. Make Prayers to the Raven: A Koyukon View of the Northern Forest. Chicago: University of Chicago Press, 1983.

KATMAI NATIONAL PARK AND PRESERVE

Griggs, Robert F. The Valley of Ten Thousand Smokes. Washington, D.C.: National Geographic Society, 1922.

GREAT BASIN NATIONAL PARK

Cohen, Michael P. A Garden of Bristlecones: Tales of Change in the Great Basin. Reno, NV: University of Nevada Press, 1998.

BRYCE CANYON NATIONAL PARK

Scrattish, Nicholas. Historic Resource Study: Bryce Canyon National Park. U.S. Dept. of the Interior, National Park Service, 1985.

CARLSBAD CAVERNS NATIONAL PARK

Lee, Willis T. "A Visit to Carlsbad Cavern." National Geographic Magazine 45.1 (1924): pp. 1-40.

GLACIER BAY NATIONAL PARK AND PRESERVE

National Park Service. Glacier Bay National Park and Preserve. 28 June 2006. <http://www.nps.gov/glba/InDepth/>

GRAND TETON NATIONAL PARK

Adams, Ansel. My Camera in the National Parks. Boston: Houghton Mifflin and Co., 1950.

ARCHES NATIONAL PARK

Williams, Terry Tempest. Coyote's Canyon: A Collection of Native American Legends. Photographs by John Telford. Salt Lake City: Peregrine Smith Books, 1989.

ISLE ROYALE NATIONAL PARK

Allen, Durward L. Wolves of Minong: Their Vital Role in a Wild Community. Boston: Houghton Mifflin and Co., 1979.

GREAT SAND DUNES NATIONAL PARK AND PRESERVE

Walsenburg Independent, 1946.

DEATH VALLEY NATIONAL PARK

Burnham, Philip. Indian Country, God's Country: Native Americans and the National Parks. Washington, D.C.: Island Press, 2000.

SAGUARO NATIONAL PARK

From the "Voices of a Desert" slide program at the Red Hills Visitor Center, Saguaro National Park, Arizona.

BLACK CANYON OF THE GUNNISON NATIONAL PARK

Wright, Harvey C. A Winter in the Black Canyon of the Gunnison, 1882-83. Unpublished, 1905.

GREAT SMOKY MOUNTAINS NATIONAL PARK

Jerry Wolfe, a Cherokee elder, 2000.

DRY TORTUGAS NATIONAL PARK

Audubon, John James. The Birds of America, from Drawings Made in the United States and their Territories. 7 vols. New York: J.J. Audubon; Philadelphia: J.B. Chevalier, 1840-1844.

SHENANDOAH NATIONAL PARK

Roosevelt, Franklin D. Dedication Speech. Shenandoah National Park, Big Meadows, VA. 3 July 1936.

JOSHUA TREE NATIONAL PARK

Beasley, Jr., Conger. The Oasis Story. 31 Oct. 2002. National Park Service – Joshua Tree National Park. 28 June 2006. <http://www.nps.gov/jotr/culture/mara/mara.html>

CAPITOL REEF NATIONAL PARK

Crampton, C. Gregory, ed. "Military Reconnaissance in Southern Utah, 1866." Utah Historical Quarterly 32 (1964): pp. 145-146.

CHANNEL ISLANDS NATIONAL PARK

Sanchez, Georgiana Valoyce. From Island Views, the newspaper of Channel Islands National Park, 2005-2006.

BADLANDS NATIONAL PARK

O'Harra, Cleophas C. The White River Badlands. Rapid City, SD, 1920.

MAMMOTH CAVE NATIONAL PARK

Emerson, Ralph Waldo. "Illusions." The Conduct of Life. Boston: Ticknor and Fields, 1860.

BIG BEND NATIONAL PARK

Abbey, Edward. One Life at a Time, Please. First Edition. New York: Holt, 1988.

THEODORE ROOSEVELT NATIONAL PARK

Roosevelt, Theodore. The Works of Theodore Roosevelt. Memorial Edition. 24 vols. New York: Charles Scribner's Sons, 1926.

EVERGLADES NATIONAL PARK

Douglas, Marjory Stoneman. The Everglades: River of Grass. New York: Rhinehart, 1947.

VIRGIN ISLANDS NATIONAL PARK

Galeano, Eduardo. Memory of Fire: Genesis. New York: Pantheon Books, 1985.

CANYONLANDS NATIONAL PARK

Secretary of the Interior Stewart L. Udall, 1964.

NORTH CASCADES NATIONAL PARK

From the report of Henry Custer, assistant of reconnaissances made in 1859 over the routes in the Cascades Mountains in the vicinity of the 49th parallel. May 1866.

REDWOOD NATIONAL AND STATE PARKS

Zahniser, Ed. Redwood Official National and State Park Handbook. National Park Service, Harpers Ferry Center, Division of Publications, 1997. p. 71.

BISCAYNE NATIONAL PARK

Munroe, Ralph Middleton and Vincent Gilpin. The Commodore's Story. New York: I. Washburn, 1930.

GUADALUPE MOUNTAINS NATIONAL PARK

Cheek, Lawrence W. "Lonely, Lovely, Utterly Unforgettable." Sunset 31 Oct. 2001: pp. 34-37.

VOYAGEURS NATIONAL PARK

Jaques, Florence Page and Francis Lee Jaques. Canoe Country. Minneapolis, MN: University of Minnesota Press, 1938.

CUYAHOGA VALLEY NATIONAL PARK

Olmsted Brothers Report on a Park System for Summit County, Ohio, 1925.

CONGAREE NATIONAL PARK

Bowen, Mike. "Preserve Proposals Would Save Swamps." The State 3 Mar. 1974.

GATES OF THE ARCTIC NATIONAL PARK AND PRESERVE

Brown, William E. and Carolyn Elder. This Last Treasure: Alaska National Parklands. Anchorage, AK: Alaska Natural History Association, 1982.

KENAI FJORDS NATIONAL PARK

McClanahan, Alexandra J. Our Stories, Our Lives. Anchorage, AK: The CIRI Foundation, 2002.

KOBUK VALLEY NATIONAL PARK

Andrews, Susan B. and John Creed, eds. Authentic Alaska: Voices of Its Native Writers. Lincoln, NE: University of Nebraska Press, 1998.

LAKE CLARK NATIONAL PARK AND PRESERVE

Keith, Sam. One Man's Wilderness: An Alaskan Odyssey. The journals and photo collection of Richard Proenneke. Anchorage, AK: Northwest Publishing Co., 1973.

WRANGELL-ST. ELIAS NATIONAL PARK AND PRESERVE

Herben, George. Picture Journeys in Alaska's Wrangell-St. Elias: America's Largest National Park. Portland, OR: Alaska's Northwest Books, 1997.

NATIONAL PARK OF AMERICAN SAMOA

Young, Donald, ed. The Sierra Club Guides to the National Parks of California, Hawai'i, and American Samoa. New York: Stewart, Tabori & Chang, 1996.

Acknowledgements

With extra special thanks to Stan Jorstad's children, Jan and Steve, and the rest of the Jorstad family, Tom, Mary Ann, Byron Burk and Dan Otto

With extra special thanks to Clare Kanter of Nature Valley, and Tom McCarthy, Janis Martin and Mark Larson of Campbell Mithun, whose commitment and support helped make this book a reality

With extra special thanks to Bruce Starrenburg from Lightbox in East Dundee, Illinois, for his superb photography scans

With extraordinary gratitude to Michael Cohen from New York City, whose creative skills and good nature yielded this beautifully designed book

With great appreciation to Joel Saferstein and Alex Frenkel from *American Park Network*, and especially to Al and Mona Saferstein for their constant encouragement and support

Thank you to David for always being there for his brothers

With special thanks to John Mitchell (retired, National Geographic Magazine)

With special thanks to the staff and board of The Yosemite Fund

With special thanks to essayists Edwin Bernbaum, Ruth Rudner and Alfred Runte

With special thanks to Vin Cipolla, John Reynolds and Eddie Gonzalez of the National Park Foundation

With special thanks to Brad Anderholm and Kevin Kelly of Delaware North Companies Parks & Resorts

Thanks to the Yosemite Institute and the Yosemite Association staff, board and volunteers
With special thanks to Jeremy Spoon and Jonah Steinberg of The Mountain Institute for research

With special thanks to Melinda Bollar Wagner at Radford University, VA and her students for research

With extra special thanks to Meryl Rose, Victoria Mates, Michael Tollefson, Kevin Cann of the National Park Service, Kathy Dimont and Ariel Kelly

With special thanks to Ray Santos, Kristin Ramsey, Chris Edison, Sheree Peshlakai, Adrienne and Kyri Freeman, Linda Eade, Nick Parker of the National Park Service, Jan W. Van Wagtendonk of the U.S. Geological Survey, Laurel Boyers, April Stowell, and Amma George

With special thanks to Kent Cave of the National Park Service at Great Smoky Mountains and the staff and volunteers at Sugarlands Visitor Center

With special thanks to Terry Maddox and staff and board of the Great Smoky Mountains Association

Thank you to Les, Dick and Charles at Weiser, LLC for believing in our mission to support national parks and public lands, and for being so generous with their time and expertise

Thanks to Lindy for her friendship and ongoing support of the great outdoors

Thanks to Gus and Chloe, and Charlotte and Orville for their constant encouragement

With special appreciation and thanks for the efforts of all the following NPS staff, cooperating association employees and volunteers:

Jim Adams
Mike Adams
Judy Alderson
Diane Allen
Joan Anzelmo
Craig Axtell
Nancy Bailey
Terry Baldino
Chuck Barat
Colleen Bathe

Jonathan Bayless
Charles Beall
Barbara Beroza
Marc Blackburn
Martha Bogle
Tyrone Brandyburg
Gary Bremen
Laura Buchheit
Jerry Burgess
Charlie Callagan
Dominic Cardea
Dave Carney
Lyn Carranza
Vickie Carson
Diane Chalfant
Steve Chaney
Bob Chenoweth
Anita Clark
Jill Click
Cathleen Cook
Greg Cox
Norma Craig
Peter Craig
Sarah Craighead
Tim Cruze
Ben Cunningham-Summerfield
Kimberly Cunningham-Summerfield
Patte Danisiewicz
Tami DeGrosky
Carolyn Duckworth
Betsy Duncan-Clark
Margaret Eissler
Reed Engle
Tom Farrell
Gregg Fauth
Josie Fernandez
Mino Fialua
Kimberly Finch
Kris Fister
Sheri Forbes
Dave Forgang
Phil Francis
Art Frederick
Larry Frederick
Andy Fristensky
Lina Fuamatu
Paul Gallez
Lisa Garvin
Scott Gediman
Mike Giannechini
Paul Gleeson
Nardia Goldin
Susan Gonshor
Phyllis Green
Karen Haner

Joel Hard
Andi Heard
Judy Helmich-Bryan
Paul Henderson
Bob Hoff
Bill Hulme
Toni Huskey
Christine Hutchinson
Amy Ireland
Jim Ireland
Phil Johnson
Shelton Johnson
Kristen Kaczynski
Bruce Kaye
Dan Kimball
John King
Mary Kline
Bill Laitner
Mardie Lane
Hallie Larsen
Gene Lew
Bridget Litten
Chip Littlefield
Calvin Liu
Miriam Luchans
Joy Lyons
Bob Love
Burrel Maier
Director Fran Mainella
Diane Mallickan
Tim Manns
Kelly Jean Maples
Alvis Mar
Bahia Mar
Marie Marek
Mary Martin
Cyndi Mattiuzzi
Marsha McCabe
Tom Medema
Karen Michaud
Marianne Mills
George Minnigh
Jerry Mitchell
Roberta Moore
Wanda Moran
Jen Nersesian
Cindy Nielsen
Timothy Nitz
Rick Nolan
Ellen Ogle
Marty O'Toole
Cindy Orlando
Marea Ortiz
Nanette Oswald
Julia Parker

Smitty Parratt
Cherry Payne
Patrick Pilcher
Valerie Pillsbury
Tom Pittenger
Jack Phinney
Kevin Poe
Rick Potts
Kathleen Przbylski
Fran Rametta
Rosemarie Salazar
Jeanne Schaaf
Chris Schierup
Alan Scott
Richard West Sellars
Dean Shenk
Tessy Shirakawa
Sharon Shugart
Michael Smithson
Carol Sperling
Kathy Steichen
Linda Stoll
Michael Stuckey
Epi Suafoa
William Supernaugh
Ron Terry
Paul Thomas
Mary Lou Tiede
Tavita Togia
Jeffrey Trust
William Tweed
Steve Ulvi
Liz Valencia
Tom Vandenberg
Jennie Vasarhelyi
Sam Vasquez
Deb Wade
Bill Walters
Erik Westerlund
Russ Whitlock
Jock Whitworth
Judy Wohlert
Patti Wold
Dave Wood
Jacilee Wray
Paul Zaenger
Joe Zarki

And to all National Park Service personnel, partners and volunteers who help preserve and sustain the natural and cultural wonders that are our national parks.